I KNOW AN ARTIST

The inspiring connections between the world's greatest artists

SUSIE HODGE

Illustrated by

Sarah Papworth

WHITE LION
PUBLISHING

Contents

Introduction

ARTISTS HAVE never worked in a vacuum. Every work of art is the culmination of many events, incidents and situations, and in one way or another, most of these are caused by associations or links with other people. These might be complete strangers or they could be known to the artists. Whatever their connection, all the artists in this book are linked by at least one other artist.

In all of our lives, we have countless links and connections with others that alter how we think or act, what we do, why we do it and where. Sometimes, these connections may seem irrelevant but end up being quite significant; at other times, they can seem important in the moment, but their effect is almost imperceptible. Many connections affect us in ways we could never anticipate, and nowhere are these things more apparent than in the lives of artists, for whom events so often manifest themselves visually through their work. One of the most fascinating aspects of art and art history is learning about these links and connections, and seeing how, why and where they occur, how they emerge and evolve into works of art or even entire art movements. For example, a chance meeting may change the way an artist views the world, uses a certain material or incorporates particular motifs into his or her work. A certain teacher may affect how a pupil works or who they admire. Then there are other types of connection: a critical review or a letter of encouragement; winning the same award, perhaps even decades apart; membership of a particular society; exhibiting together; being commissioned by the same patron; or having an affair with the same person. The possibilities are vast.

While this book is all about the connections, it is not a chronological story of those who influenced and those who were influenced. In fact, it is not chronological at all and it is not only about influences. Instead, within these pages, time flows forwards, backwards and sideways, and the artists explored are connected to each other in a whole host of ways. Here you will discover fascinating stories about famous artists and those less familiar. You will gain insights into the human side of many works of art and the personalities of those who made them, and you will see how

great works ended up being made, either through a vague or a close link with another person or people. For example, you can read about the artist who inspired Rodin's *The Kiss* — and another who wrapped it in string; the artists who struggled in Montmartre, and the probable originator of abstract painting. (Hint: it wasn't Kandinsky.) The book is filled with stories about the artists' support networks, influences and inspirations. There are those who are household names, such as Pablo Picasso, Henri Matisse and Frida Kahlo, and those who are less well-known. Many of the artists included reflect their own cultures and societies, but they also reflect other things beyond that, such as the times in which they lived or the art styles and methods they influenced, even decades later. Overall, there are eighty-four artists considered, who all worked from the end of the nineteenth century to the present day. Their connections are as varied as the art they produced.

Sarah Papworth's vibrant and original illustrations bring all the artists and their stories alive, linking them together and creating their own unique world. These links are just a few of the thousands that have occurred and are still occurring in the art world, and that have helped to challenge and change the face of art over the past couple of centuries. I hope that the stories inspire you to go and see some of the artworks and to look at them with a fresh understanding and pleasure. Art is one of those things that rewards you: the closer you look, the more you see. After reading this book, hopefully you will see even more in the work of the artists featured.

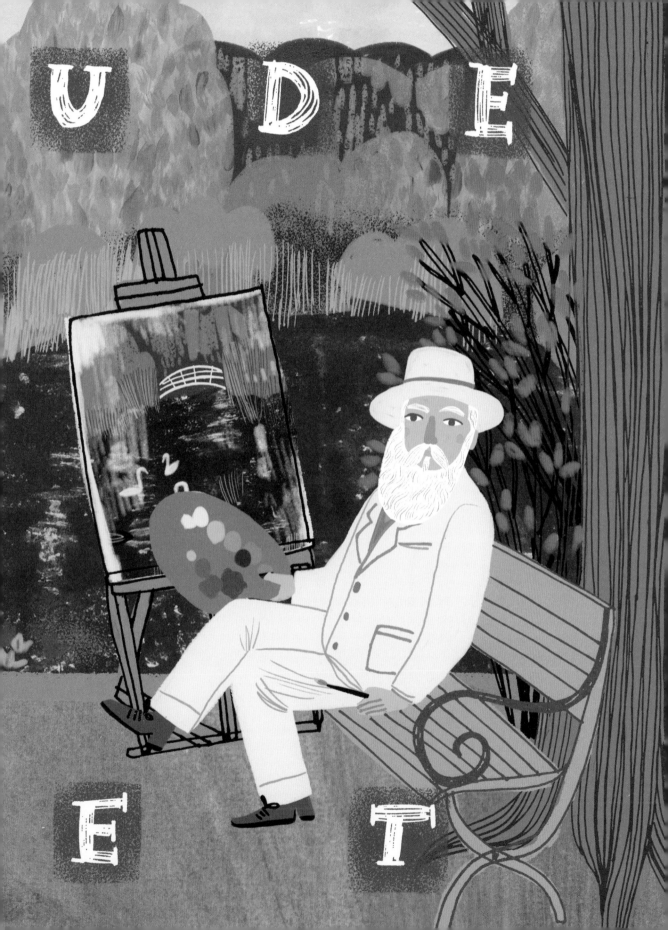

Was particularly influenced by the painting *Déjeuner sur l'Herbe* by

Helped inspire the painting *Carnation, Lily, Lily, Rose* by

ONE OF the founders of Impressionism, Oscar-Claude Monet (1840–1926) remained faithful to the movement's aims throughout his life: painting *en plein air*, capturing fleeting moments and using colour to depict the effects of light. Even the name Impressionism came from the title of one of his paintings. As a teenager growing up in Le Havre on the Normandy coast, he began painting outdoors with Eugène Boudin (1824–98). At that time, although some artists made outdoor sketches or visual notes, most paintings were completed in artists' studios. By painting directly in front of his subject, Monet believed he was capturing light and colour as accurately as possible, and using bright pigments, he rendered everything with bold, broken brushmarks. From 1874 to 1886, he helped to organise, and exhibited in, five of eight

independent exhibitions with the artists known as the Impressionists. Although his style changed in later life, he always aimed to capture spontaneous, passing moments, representing the flickering sensations that our eyes naturally see. At first, his sketchy, seemingly unfinished paintings attracted ridicule and derision, but Impressionism later became one of the most significant art movements of the late nineteenth century. Because of his commitment to the movement, Monet's colourful paintings earned him the epithet 'the father of Impressionism'.

Throughout his life, Monet produced more than 2,000 paintings and 500 drawings, but initially he faced fierce family opposition. His father wanted him to join the family grocery and ship chandlery business, and his aunt would

MARY CASSATT

AUGUSTE RODIN

only support him in his artistic ambitions if he undertook conventional art training. After moving to Paris at the age of nineteen, Monet enrolled at a small studio that disregarded established teaching methods, where he mixed with the avant garde of the day. However, his family cut him off financially and he was often so poor that he could not afford to feed himself, let alone his wife and child. Despite the hostility towards him, Monet persevered. After more than twenty years, he achieved fame and financial success, and in 1883 bought a house in the village of Giverny outside Paris. By 1890, he was wealthy enough to buy a plot of land next to it. There, he employed six gardeners to build a garden and an enormous pond, which was filled with water lilies and spanned by a Japanese-style bridge. For the last thirty years of his life, the artist painted this untiringly in different lights and seasons.

Monet once told a journalist: 'I perhaps owe it to flowers for having become a painter.' His paintings of flowers and gardens broke with artistic traditions and generally elevated the status of such themes. He especially liked to paint his own gardens, first at Argenteuil, then at Vétheuil, and finally at Giverny. Similarly inspired by nature, Anya Gallaccio (b.1963) has frequently made flowers a prominent subject. In the same way that Monet broke artistic boundaries with his monumental paintings of lilies, so Gallaccio creates installations consisting of huge expanses of actual flowers, as seen in *preserve 'beauty'* (1991–2003).

FREQUENTLY INCORPORATING organic material, such as fruit, vegetables and plants, in her work, Anya Gallaccio explores the relentlessness of time and the processes of transformation and decay. Her installations of natural materials change through decomposition during their display period, so they look and smell wonderful at the start, but by the end of an exhibition they are quite the opposite. For example, *Red on Green* (1992) was a huge rectangle of 10,000 fresh rose heads on a bed of their stalks, left to decompose. Unpredictability is important. She says: 'I have a notion about a material and about how [it] might react, but I haven't got a preconceived notion about how it will turn out . . . You get more experienced about spaces and materials, so you can guess how the material will respond. But I try really hard to have some element where I don't really know.'

Gallaccio gained international recognition after participating in the 'Freeze' exhibition in London in 1988, organised by Damien Hirst (b.1965). The exhibition included the work of sixteen young British artists, most of whom attended Goldsmiths College together, and it elicited the monikers YBAs (Young British Artists) and Britart.

Inspired by a wide range of influences, from Italian fresco painting to the Minimalist works of Donald Judd (1928–94), Gallaccio also uses more traditional sculptural materials, such as bronze. For example, *Because I Could Not Stop* (2002) is a bronze sculpture of a tree adorned with real apples that were left to rot. Her associations with decay and death form alternatives to the traditional memento mori, which remind viewers of the effects of time on both beauty and life. A professor in the department of visual arts at the

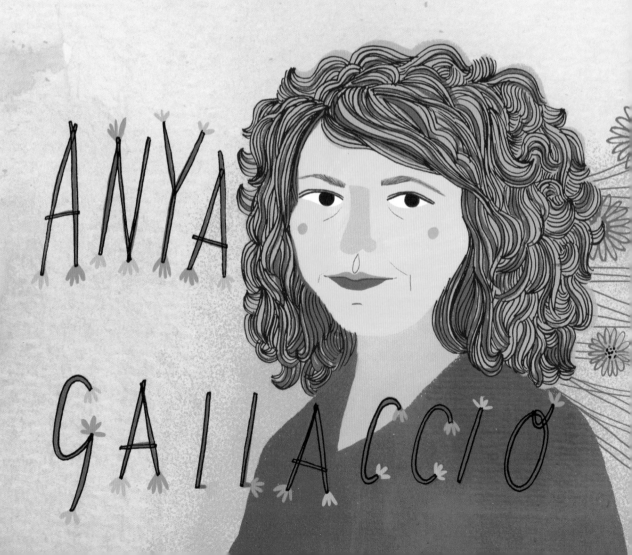

ANYA
GALLACCIO

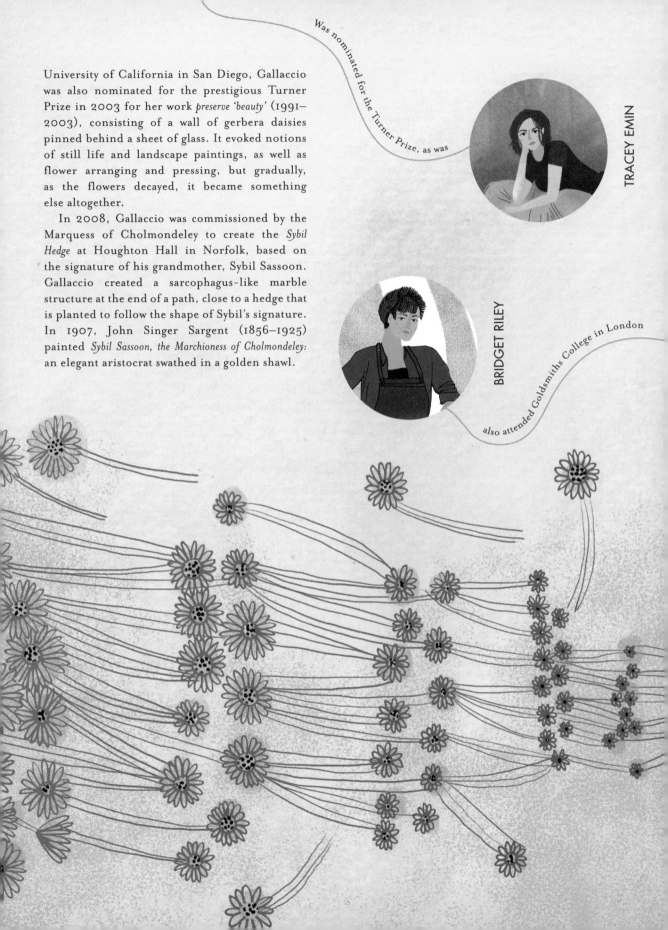

University of California in San Diego, Gallaccio was also nominated for the prestigious Turner Prize in 2003 for her work *preserve 'beauty'* (1991–2003), consisting of a wall of gerbera daisies pinned behind a sheet of glass. It evoked notions of still life and landscape paintings, as well as flower arranging and pressing, but gradually, as the flowers decayed, it became something else altogether.

In 2008, Gallaccio was commissioned by the Marquess of Cholmondeley to create the *Sybil Hedge* at Houghton Hall in Norfolk, based on the signature of his grandmother, Sybil Sassoon. Gallaccio created a sarcophagus-like marble structure at the end of a path, close to a hedge that is planted to follow the shape of Sybil's signature. In 1907, John Singer Sargent (1856–1925) painted *Sybil Sassoon, the Marchioness of Cholmondeley:* an elegant aristocrat swathed in a golden shawl.

Was nominated for the Turner Prize, as was

TRACEY EMIN

BRIDGET RILEY

also attended Goldsmiths College in London

JOHN

SINGER
SARGENT

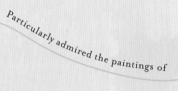

Particularly admired the paintings of

AN AMERICAN who spent most of his life in Europe, and an accomplished pianist who often played for his sitters, John Singer Sargent reflected the elegance of the Edwardian era. Like other American artists such as James Abbott McNeill Whistler (1834–1903) and Mary Cassatt (1844–1926), Sargent trained in Paris, from where in 1874 a fellow art student, Julian Alden Weir (1852–1919), wrote: 'I met this last week a young Mr Sargent about 18 years old and one of the most talented fellows I have ever come across; his drawings are like Old Masters, and his colours are equally fine.'

Sargent was born in Florence to American expatriates who constantly moved around Europe as their three children grew up. The first time he visited the United States, he was twenty years old and was travelling there to secure his US citizenship. From early on, his mother nurtured his interest in art, and he studied briefly at Florence's Accademia di Belle Arti, and also in Paris at the studio of portrait painter Carolus-Duran (1837–1917) and at the École des Beaux-Arts.

Although he preferred painting landscapes, figures and murals, Sargent became the favourite portrait painter of the upper classes. Over his career, he produced some 900 oil paintings, more than 2,000 watercolours and a vast number of sketches and drawings. His style fuses the sketchy brushwork that he learned from his friend Claude Monet; techniques from the art of Titian (c.1488/90–1576), Anthony van Dyck (1599–1641), Diego Velázquez (1599–1660), Thomas Gainsborough (1727–88), Édouard Manet (1832–83) and Japanese *ukiyo-e* paintings and prints; and his own astute observations. In 1897, the Metropolitan Museum of Art in New York nicknamed him 'the Van Dyck of our times', and in 1910, Walter Sickert (1860–1942) published an article comparing the clamour for his art to religious devotion, labelling it 'Sargentolatry'. Yet Sargent's work also provoked scandal, and soon after his death, he was judged adversely for not embracing modern movements such as Cubism and Fauvism. After the influential English art critic Roger Fry (1866–1934) dismissed his work as lacking aesthetic quality at the 1926 retrospective of his work in London, he became disregarded, but in the early twenty-first century he began to be appreciated once more.

Inspired in particular by the styles and palettes of Velázquez and Manet, Sargent painted *Madame X* (1884), a portrait of a society beauty in a risqué dress. The ensuing scandal compelled the artist to leave Paris for London. In 1884, after Manet's death, Sargent attended his studio sale and bought the painting *Mademoiselle Claus* (1868). The subject was Fanny Claus, Manet's wife's closest friend, and the work was a study for one of Manet's most famous paintings, *Le Balcon* (1868–69).

TRADITIONAL ARTISTS tried to convey permanence, but Édouard Manet created a sense of spontaneity. He later became recognised as one of the most original and influential painters of the nineteenth century and a key figure in the development of modern art. Yet he did not consider himself to be a revolutionary; he simply felt that art had become disconnected from life.

From a family of diplomats and judges, Manet did not need to earn a living from painting, but he longed for recognition from the French art authorities and was shocked by the scandal his paintings provoked. However, the Impressionists admired him, and although he never exhibited with them, he led their discussions, advocating novel ideas such as painting *alla prima* (at first attempt) rather than building up paint in layers. His first picture to cause uproar was *Le Déjeuner sur l'Herbe* (*Luncheon on the Grass*) of 1863. It was rejected by the Salon, the official art exhibition in Paris, and exhibited instead at the Salon des Refusés (the exhibition of rejected art). A naked woman sitting between two clothed men was shocking enough, but the paint was also thin and sketchy and the image unrealistic and flat-looking.

Full of contradictions, Manet's paintings not only included landscapes, portraits, everyday scenes and still lifes, but also scenes of history that conventional artists painted, although executed in his unconventional style. He was an accomplished draughtsman and a skilled printmaker and also used pastels proficiently. His astute observations of the people, places and events around him were his main inspirations, which the French art academy considered to be one of his greatest mistakes — modern life was deemed too unsightly for art. Despite this, Manet aimed to learn as much as possible from the great masters before him, and he travelled across Europe studying art. In Spain, the work of Diego Velázquez had a particularly powerful effect on him. He began to incorporate some of Velázquez's ideas in his own work, including dramatic viewpoints, Spanish subjects and black paint to emphasise contrasts of light. He spent many hours in the Louvre in Paris, studying the work of Spanish artists, and at one point he was nicknamed 'the Spanish Parisian'.

In 1862, Manet was copying Velázquez's portrait of the Infanta Margarita in the Louvre and began to chat with another artist who was doing the same. At twenty-seven, Edgar Degas (1834–1917) was three years younger, and also from a wealthy, although less conventional, family. Despite their contrasting personalities and artistic interests, they became friends.

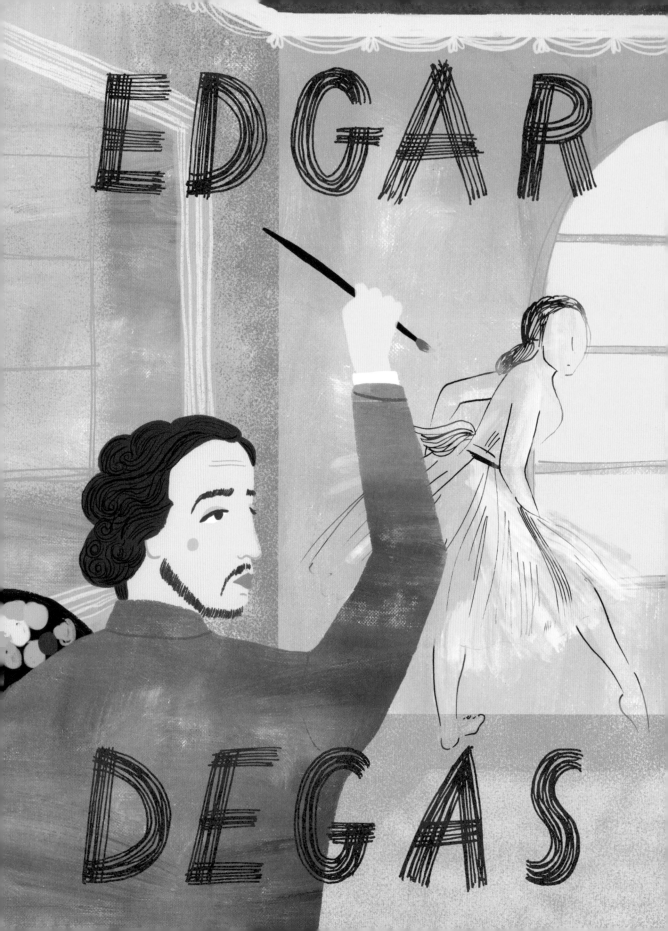

Supported and encouraged

SUZANNE VALADON

Rejected the spontaneous methods of the Impressionists alongside

PAUL CEZANNE

RENOWNED FOR his vibrant images of dancers, racecourses and women washing, Edgar Degas was associated with the Impressionists, but his approach was different and he rejected the label. Nonetheless, he helped to organise their independent exhibitions that were held from 1874 to 1886, and he took part in all but one of them. While the Impressionists painted directly from nature, capturing fleeting effects of light, Degas was more concerned with accurate drawing and movement. The Impressionists often painted landscapes *en plein air*, but Degas preferred to complete his work in the studio.

An admirer of Jean-Auguste-Dominique Ingres (1780–1867), Degas initially studied classical art, but soon began combining conventional approaches with contemporary ideas. Many of his methods were also unusual. He often diluted his paints and turned his pastels into paste, then used them over paint. Over his career, he produced paintings, sculpture, prints, drawings and photographs, always aiming to capture movement and spontaneity, but spending hours studying, planning, sketching and photographing.

The son of a wealthy banker, Degas grew up in an upper-class family, but on leaving school he registered to become a copyist at the Louvre. His father was uneasy about his eldest son becoming an artist, so to appease him Degas started training as a lawyer. But within a short time, he left law school and studied with Louis Lamothe (1822–69), a former student of Ingres, who taught him the importance of drawing and encouraged his passion for Italian art. Later, he met Ingres, who told him to concentrate on drawing. He also took classes at the École des Beaux-Arts and went to Italy to study the great Renaissance masters. On his return, he painted portraits and historical subjects, but after meeting Édouard Manet in 1862, he focused on scenes of modern life, such as racetracks, café interiors, dance studios and theatres. After the 1870s, ballet dancers became his favourite theme, often depicted from dramatic angles or with limbs 'cut off' at the edges of his canvases. These original ideas derived from his understanding of photography.

An intelligent man, Degas had poor eyesight and was often irritable. Although he never married, he was fascinated by women's movements and postures. He first met Mary Cassatt when he visited her Montmartre studio in 1877, and he invited her to exhibit with the Impressionists. 'Most women paint as though they are trimming hats, but not you,' he said. It was the beginning of a friendship that lasted for nearly forty years.

AFTER SPENDING much of her childhood in France and Germany, Pennsylvania-born Mary Stevenson Cassatt moved to Paris at the age of twenty to complete her art education, and lived and worked there for most of the next sixty years. As a woman, she was barred from the École des Beaux-Arts, so she took private lessons with the academic painter Jean-Léon Gérôme (1824–1904) and also copied Old Master paintings in the Louvre. During the Franco-Prussian War of 1870–71, she returned to Philadelphia, but went back to Europe as soon as it was over. Cassatt made a living painting portraits of wealthy American women who visited Paris for its culture and fashions, and much of her work was accepted for the prestigious annual Salon. In 1877, Edgar Degas invited her to exhibit with the group of artists who, rejected by the art establishment, had been holding their own independent exhibitions since 1874 and who had been nicknamed the Impressionists, the Independents and the Intransigents. Influenced strongly by their ideas, especially by Degas and Édouard Manet, Cassatt moved away from her accepted style and began using small, sketchy brushmarks, lighter colours and compositions that showed the influences of photography and Japanese art. She began painting urban life, but as a woman she could not focus on the same scenes as the Impressionists, so rather than city streets, cafés and bars, she painted mother and child images, or females in bourgeois interiors, at the theatre or in gardens. Her models were family members and friends, especially her sister. She also experimented with printmaking and pastels.

In her determination, style and insightful evocations of women's lives, Cassatt was unique. She also had business acumen and served as

an advisor to several leading art collectors, persuading them to donate their acquisitions to American galleries. Through her friendships and professional relationships with artists, dealers and collectors on both sides of the Atlantic, she helped to establish the American taste for Impressionist art.

In the 1890s, when she was well known, Cassatt met a fellow American who also went to Paris to study art. Lucy Bacon (1857–1932) had studied in New York, but moved to Paris in 1892 and enrolled at the renowned Académie Colarossi. Dissatisfied with the instruction there, she asked Cassatt for advice. Cassatt introduced her to Camille Pissarro (1830–1903) and Bacon travelled from Paris to Éragny-sur-Epte where Pissarro was living, to study with him. A few years later, she returned to the United States and established her career as an Impressionist.

Paved the way for feminism in art, as did

GEORGIA O'KEEFFE

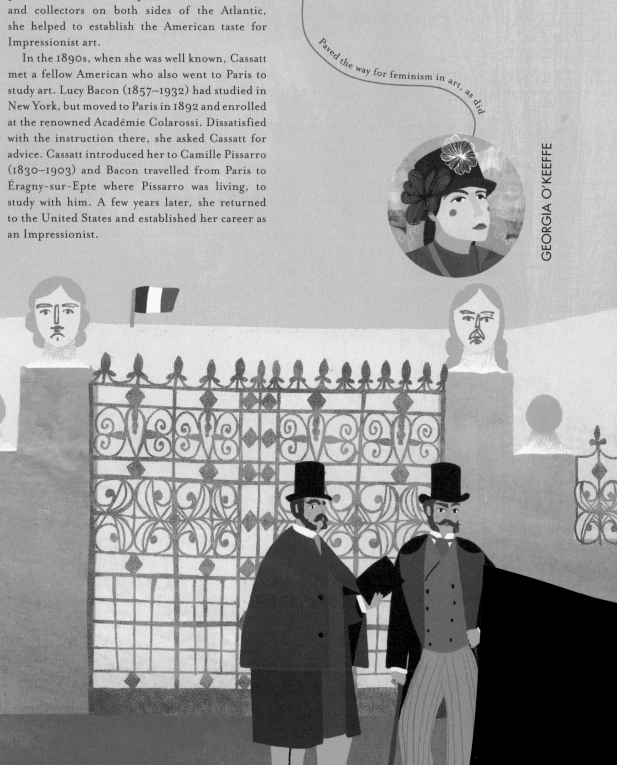

Other students who attended the Académie Colarossi in Paris include

CAMILLE CLAUDEL

THE ONLY known Californian artist to have studied under the French Impressionist Camille Pissarro, Lucy Bacon was born in New York and studied art there. Although it was difficult at that time for a woman to become an artist, she was supported and encouraged by her family, especially by her older brother Albert S. Bacon, who, in 1892, moved with his wife, Mary, and their children to California, where he established a successful footwear business.

That same year, Mary Cassatt, who was living and working in Paris, was commissioned to paint a mural for an exhibition in Chicago. When the mural was displayed, it received a lot of publicity, which may have given Bacon the idea to contact Cassatt, and that year she travelled to Paris and enrolled at the Académie Colarossi. Before long though, Bacon asked Cassatt for advice about alternative teaching. Cassatt introduced her to

LUCY
ACON

Pissarro, whose inspired teaching of artists was renowned. Pissarro encouraged Bacon to brighten her palette, to use small, broken brushmarks and to paint *en plein air*, all of which were elements of the Impressionist technique. She also followed Pissarro to Éragny-sur-Epte, north-west of Paris, to continue studying with him.

By 1898, Bacon was back in the United States, living near her brother in California. She never married, and health problems prevented her from painting full-time. She taught in a school, painted from her home studio and exhibited in places such as the San Francisco Art Association. She was related through the marriage of her niece to an interior design firm and art gallery, Vickery, Atkins & Torrey, and through them and her friends in France, she helped to introduce Impressionism to California. In the spring of 1902, Bacon's paintings were exhibited at the Mark Hopkins

Institute of Art in San Francisco. However, within three years, she had stopped painting completely. Although she continued to teach art, she devoted herself to Christian Science. She also became involved with a couple of groups that organised exhibitions of art by Native American artists.

Despite Bacon's negative views about the Académie Colarossi, it was one of the few art colleges that accepted female students and allowed them to draw from the nude male model, which was extremely radical for the time. It attracted a large number of foreign art students, especially from the United States, and several subsequently notable female artists, including the Scottish Impressionist Bessie MacNicol (1869–1904), the Canadian Impressionist Emily Carr (1871–1945) and the German Expressionist Paula Modersohn-Becker (1876–1907), who enrolled there eight years after Bacon.

PAULA

MODERSOHN

-BECKER

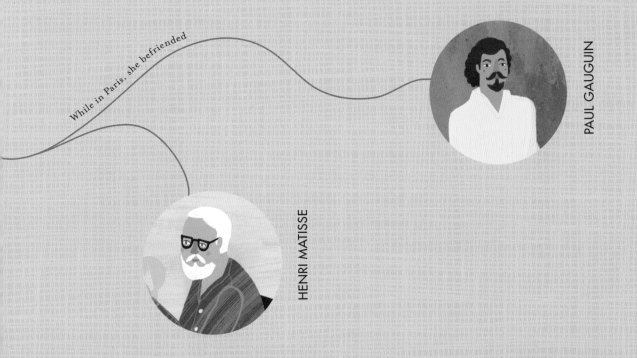

While in Paris, she befriended

PAUL GAUGUIN

HENRI MATISSE

THE FIRST woman to paint a naked self-portrait, Paula Modersohn-Becker was one of the most important representatives of early Expressionism. Her parents, however, wanted her to become a teacher, and once she was married, they told her to abandon her 'egotism' and carry out her wifely duties.

Born Paula Becker in Dresden-Friedrichstadt, she grew up in a cultured and intellectual environment. In 1888, she received her first drawing instruction at St John's Wood Art School in London. In 1893, she began teacher training and was introduced to the artists' colony at Worpswede, which included Otto Modersohn (1865–1943), Fritz Mackensen (1866–1953), Fritz Overbeck (1869–1909) and Heinrich Vogeler (1872–1942). She also took private painting lessons, and after completing her teacher training course, she studied painting and drawing, sponsored by the Verein der Berliner Künstlerinnen (Union of Berlin Female Artists). In 1900, she travelled to Paris to study drawing and anatomy, and was so stimulated by the city that she boldly wrote to Modersohn, one of the Worpswede artists she had befriended – who was married. She begged him to join her, with or without his ill wife. At first he refused, but four months later, after the death of his wife, he went to Paris, and he and Paula became engaged.

Immediately, her father told her to forget about her first prize at the Académie Colarossi and to focus on her husband. At first she tried, but in 1902 she wrote: 'Marriage does not make one happier.' Later that year, she wrote to her mother: 'I am going to become somebody', and she began painting again. Initially, Modersohn described her as 'the best woman painter in Worpswede'. Soon, however, he said she was 'falling prey to the error of preferring to make everything angular, ugly, bizarre, wooden'.

Her subjects were frequently women, often nude, or ripe fruit. At the age of thirty, she travelled to Paris alone, writing to Modersohn to ask for money for her rent and models' fees. Within a few months, however, they reunited and she became pregnant. In 1907, she gave birth to a daughter, but was ordered to stay in bed. After eighteen days, on standing, she collapsed and died from a post-partum embolism caused by lying down for so long. She was thirty-one and had sold only three paintings in her lifetime.

Another artist who had also taken advantage of the rare opportunity for women art students was Käthe Kollwitz (1867–1945), who attended the Berlin School for Women Artists. Her work expressed great compassion, particularly for women suffering universal human experiences.

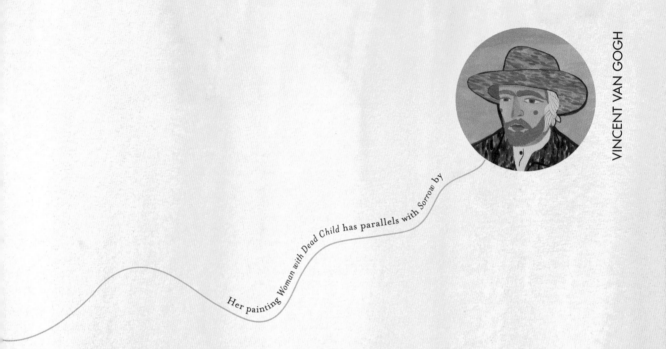

Her painting *Woman with Dead Child* has parallels with *Sorrow* by

KNOWN ESPECIALLY for her raw, empathetic, monochrome prints and sculptures, Käthe Kollwitz (née Schmidt) was born in the Prussian city of Königsberg (now Kaliningrad, Russia). Inspired by her family's unorthodox opinions (for the time) that a woman could be an artist, she had fewer constraints on her career than most contemporary women.

The fifth child in a middle-class, politically progressive family, Kollwitz suffered from anxiety after her younger brother, Benjamin, died of meningitis at just one year old. When she was twelve, she took drawing lessons with a local engraver. Two years later, she met Karl Kollwitz, a medical student, and they soon became engaged. Unusually for the period, her father encouraged her to put her art career before marriage. Despite the encouragement, it was difficult for Kollwitz to go further; female students were barred from most colleges. Nevertheless, she managed to study in Berlin and Munich. In Berlin, she studied with Swiss painter, etcher and sculptor Karl Stauffer-Bern (1857–91), who introduced her to the work of his friend Max Klinger (1857–1920). Klinger's etchings had a huge influence on her style, subjects and choice of materials.

In 1891, she married Karl, who by then was a doctor. They moved to an apartment in Berlin where Karl cared for the poor and Kollwitz had a studio. Their first child, Hans, was born in 1892, and in 1896, their second son, Peter, was born. Kollwitz taught at the Berlin School for Women Artists, and also began to create sculpture.

In 1914, Peter was killed in Flanders at the age of eighteen, and in 1942, her nineteen-year-old grandson, also called Peter, was killed in Russia. For the rest of her life, Kollwitz's etchings, woodcuts and lithographs expressed sorrow and suffering, and reflected her concerns about social injustice and the effects of poverty, hunger and war on the working classes, and especially women. Her figurative style gradually became less detailed, but remained expressive and emotive. In 1919, she became the first woman elected to the Prussian Academy of Arts, but the Nazi government forced her to resign her position in 1933 and banned her from exhibiting. In 1932, eighteen years after her son's death, she made a memorial to honour his memory.

As one of the most important experiences of Kollwitz's life, motherhood appears in many of her works, such as *Mother Holding Child in Her Arms* (1910). In a similarly strong close-up, Tamara de Lempicka (1898–1980) painted an intimate image of the same theme in 1931.

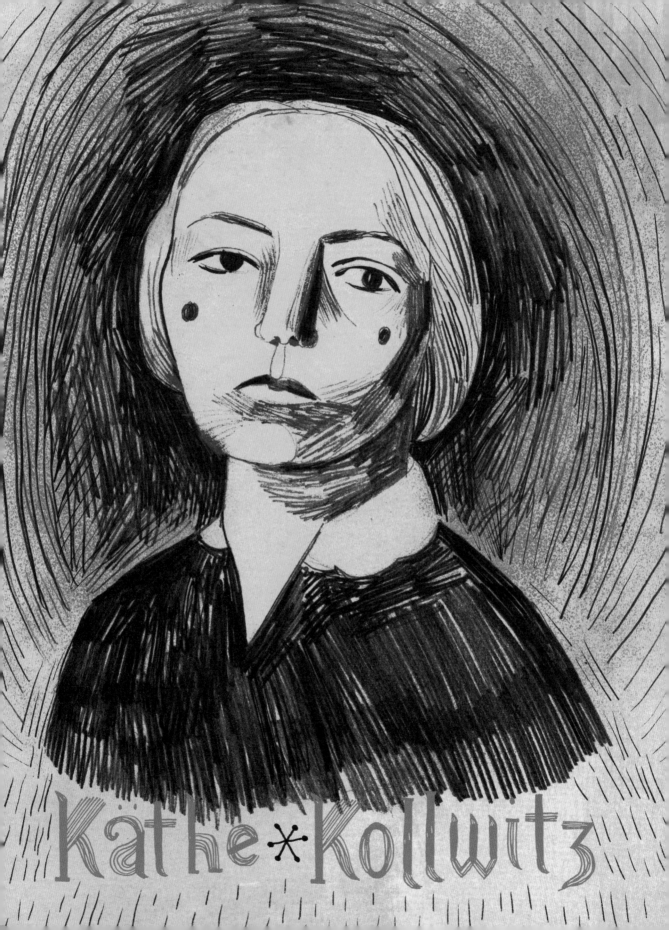
Käthe*Kollwitz

PARIS

TAMARA

DE

LEMPICKA

Her paintings were displayed in Chicago in 1933 alongside some by

EPITOMISING ART Deco, Tamara de Lempicka painted with smooth brushwork, angular contours and sculptural tones. Her distinctive painting style conveyed the glamour of the Jazz Age.

Born Maria Górska in Warsaw (then part of Russia), De Lempicka went to boarding school in Switzerland. In 1911, she spent the summer with her grandmother in Italy where she saw the work of many great Italian artists, thus igniting her passion for art. After her parents divorced, she lived in St Petersburg with her extremely wealthy aunt and uncle, who introduced her to a life of luxury. When she was fifteen, they took her to an opera where she met Tadeusz Lempicki, and three years later they married. In 1917, the Russian Revolution began and Tadeusz was arrested by the Bolsheviks. However, his young, attractive wife

used her social connections and charm to secure his release. They escaped to Paris where her family had taken refuge.

In Paris, Maria Lempicki renamed herself Tamara de Lempicka to suggest an aristocratic background, even though as a refugee her financial circumstances were dire. Her husband had no job, nor any connections in France, and by then, they also had a daughter, Kizette. De Lempicka enrolled at the Académie Ranson, where she was taught by the Nabis painter Maurice Denis (1870–1943), and at the Académie de la Grande Chaumière, where she studied with the Cubist André Lhote (1885–1962). Both Denis and Lhote influenced her profoundly. Denis imbued a sense of discipline and structure in her work, and Lhote taught her what he described

Was inspired by the 'tubism' of

FERNAND LEGER

On moving to Paris, she spent time with

PABLO PICASSO

as 'soft Cubism'. In some ways, her angular, smooth-looking images, created with exacting technical skill, recall the Neoclassical paintings of Jean-Auguste-Dominique Ingres and the Mannerist works of Bronzino (1503–72). De Lempicka painted for nine hours a day and built up a prosperous social circle. By 1923, she was exhibiting in small Parisian galleries, and the next year, her work was shown at the Salon des Femmes Artistes Modernes, also in Paris. In 1925, she had her first solo exhibition in Milan.

De Lempicka's models and patrons of both sexes were often also her lovers, and her marriage floundered. Frequently dressed in garments donated by Coco Chanel and Elsa Schiaparelli, she mixed with the avant-garde élite of Europe, including Filippo Tommaso Marinetti (1876–

1944), Jean Cocteau (1889–1963), Pablo Picasso (1881–1973) and André Gide (1869–1951).

In the late 1920s, De Lempicka was at last financially stable. She bought a three-storey house and studio on the Left Bank, and in 1933 she married Baron Raoul Kuffner, a prosperous art collector from the Austro-Hungarian Empire. Because she was partly Jewish, she and her husband moved to the United States in 1939, just before the Second World War broke out. No longer the favourite artist of the rich and famous, she lost popularity and was nicknamed 'the baroness with a brush'.

In 1925, De Lempicka won first prize at the Exposition Internationale des Arts Décoratifs et Industriels Modernes for her painting *Kizette on the Balcony* (1927). Also exhibiting there was fellow Russian artist Varvara Stepanova (1894–1958).

VARVARA

STEPANOVA

Participated in the Constructivist exhibition '5x5=25' in Moscow alongside

IN 1920, with Lyubov Popova (1889–1924), Aleksandr Rodchenko (1891–1956) and others, Varvara Stepanova co-founded the Constructivist Working Group, which aimed to design functional yet beautiful products for the working classes.

Born into a peasant family, Stepanova first met Rodchenko at Kazan Art School in Odessa. Next she studied in Moscow at the Stroganov Arts and Crafts College and privately with Konstantin Fyodorovich Yuon (1875–1958), a Russian painter and theatre designer. Within two years, Stepanova was giving private art lessons and exhibiting in Moscow; she also worked as a bookkeeper and secretary in a factory, and moved in with Rodchenko. In the year of the Russian Revolution, she began experimenting with non-objective art and visual poetry, producing collaged and handwritten books, and exhibiting in state exhibitions. Blending influences from Cubism, Futurism and traditional peasant art, she began painting in a style that became known as Constructivism. Stepanova experimented with poetry, philosophy, painting, graphic art, stage scenery construction, textiles and clothing designs. She and Rodchenko lived and worked together (they married in 1942), and in the years following the Revolution, they worked for the literary and visual arts department of the People's Commissariat for Education and Culture.

In 1921, Stepanova participated in the Constructivist exhibition '5x5=25' in Moscow with Rodchenko, Popova, Aleksandra Ekster (1882–1949) and Aleksandr Vesnin (1883–1959). They displayed abstract, geometric-style work, deliberately rejecting expressive styles and declaring the 'end of painting'. From 1923, she spent two years designing textiles with Popova, and became professor of textile design at the state-run art and technical school VKhUTEMAS. In 1925, she and Rodchenko produced posters and theatre designs for the Soviet Pavilion at the Exposition Internationale des Arts Décoratifs et Industriels Modernes in Paris. She also exhibited costume designs for the play *The Death of Tarelkin* (1869) by Aleksandr Sukhovo-Kobylin.

Stepanova's textile and fashion designs used dynamic shapes, with angular forms, abstract patterns and contrasting colours, breaking with tradition, freeing the body and emphasising clothing's functional rather than decorative qualities. Although she was inspired to develop new types of fabric, contemporary technology restricted her. Her designs incorporated triangles, circles, squares and lines superimposed onto each other. Later in her career, she returned to painting.

In 2016, the award-winning film and television director Margy Kinmonth made a film, titled *Revolution: New Art for a New World,* about Stepanova and other Russian avant-garde artists. Previously, in 2004, she had made another film about ballet dancer Rudolf Nureyev and the artist Francis Bacon (1909–92), called *The Strange World of Barry Who?*

DESPITE REPRESENTATIONAL painting being out of fashion, Francis Bacon achieved great success with his often disturbing paintings of emotionally charged figures. His raw, distorted imagery was influenced by a range of artists, including Pablo Picasso, Vincent van Gogh (1853–90), Diego Velázquez and Cimabue (1240–1302), and by Surrealism, film and photography. His style also reflected his often problematic personal life.

Named after his famous ancestor, the English philosopher and scientist, Bacon grew up in Ireland with four siblings and moved often between Ireland and England as his father served in the army. Moving home combined with severe asthma resulted in Bacon receiving an erratic education, and his father threw him out of home at the age of seventeen for dressing in his mother's clothes. He began working as an interior and furniture designer, and, despite having no formal art training, began painting in a semi-Cubist and Surrealistic style after seeing work by Picasso and the Surrealists in Paris. Yet Bacon painted only sporadically, and in 1944, he destroyed many of his paintings.

Due to his asthma, Bacon could not join the armed forces during the Second World War, and in 1944, he painted *Three Studies for Figures at the Base of a Crucifixion*, a triptych expressing the horrors of the war, the biblical Crucifixion and elements of Greek mythology. When it was first exhibited in 1945, it secured his reputation. From then on, he often painted disturbing figures, including distorted portraits, writhing bodies and screaming trapped figures, as well as unnerving interpretations of the Crucifixion.

Bacon also became renowned for his screaming popes, based on the portrait of Pope Innocent X by Velázquez in 1650, with elements of the film *Battleship Potemkin* (1925) by Sergei Eisenstein and ideas of the photographer Eadweard Muybridge

(1830–1904), whose work fascinated him. Bacon kept a collection of Muybridge's books in his studio. Generally, he preferred to work from photographs and relied on his friend John Deakin (1912–72) to take photographs of his subjects.

From the mid-1960s, Bacon mainly produced portraits of friends and drinking companions, but after his lover, George Dyer, committed suicide, his art became more sombre and inward-looking and focused on time passing and death. Bacon's agitated, sinuous brushstrokes, often smudged with sponges or pieces of rag, convey a sense of vigour. Intelligent, well-read and charismatic, the artist was passionate about painting, gambling and drinking. The human anguish he expressed in his paintings seemed unique at the time, but it was something that George Grosz (1893–1959) had also been doing through painting years before in Germany.

Was influenced by a range of artists including

VINCENT VAN GOGH

PABLO PICASSO

FRANCIS BACON

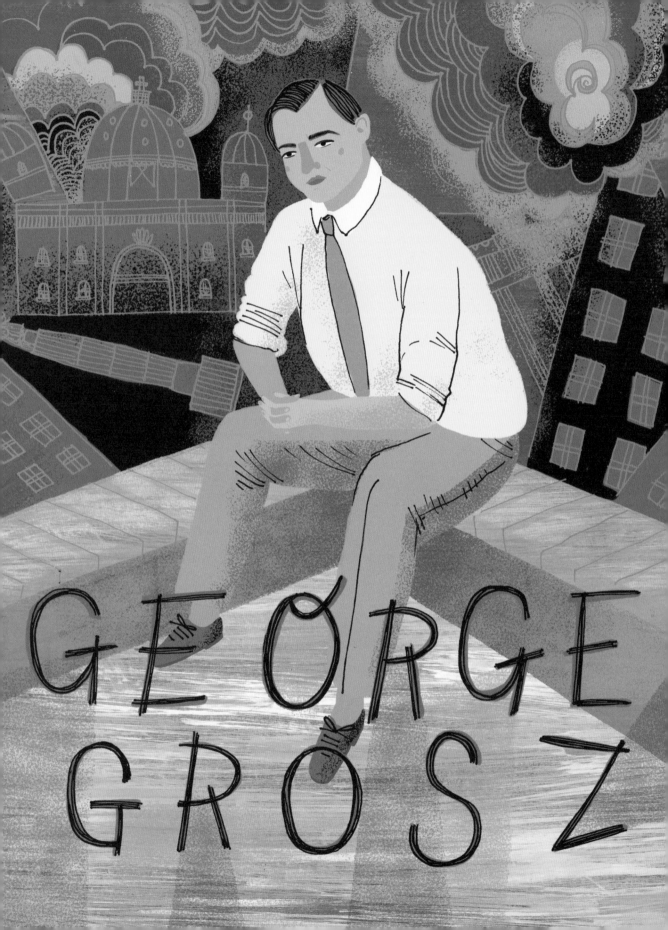

Taught at the Art Students League of New York, previously attended by

ALONG WITH his friends Otto Dix (1893–1959) and Max Beckmann (1884–1950), George Grosz was one of the main artists associated with the Neue Sachlichkeit (New Objectivity) movement in Germany during the 1920s. Also a member of the Berlin Dada group, Grosz painted to express the abhorrence he felt for the First World War.

Growing up in Germany, Grosz studied at the Dresden Academy of Fine Arts and then took a course in graphic art in Berlin, later spending several months in Paris at the Académie Colarossi. To avoid conscription, he registered for war service in November 1914, but was discharged after six months on health grounds. He was later conscripted, but suffered a nervous breakdown and was finally discharged as 'permanently unfit'. With others, he founded the Berlin branch of Dada in 1918, and after the war, he worked as an illustrator and cartoonist, although some considered his images obscene. Horrified by the human capacity for violence that he had observed during the war years, he expressed disgust through painted scenes of crime and murder on the streets of Berlin.

Inspired by the political and social satirists William Hogarth (1697–1764) and Honoré Daumier (1808–79), as well as by the opinions of other Dada artists, Grosz drew and painted expressive, distorted images, with allegorical themes influenced by Cubism and Futurism, condemning what he perceived as the depravity and immorality surrounding him in Germany. In addition to trying to make statements through art, he was involved in left-wing pacifist activity, producing drawings for satirical publications and participating in social and political protests. He later wrote: 'My drawings expressed my despair, hate and disillusionment . . .'

In 1933, just before Hitler and the Nazis took power in Germany, Grosz moved his family to the United States. He taught for years at the Art Students League of New York and illustrated for magazines including *Vanity Fair*, the *New Yorker* and *Esquire*. For four years, he ran a private art school with another artist, but closed it in 1937 when he was awarded the prestigious Guggenheim grant, which allowed him to work independently for two years. He exhibited regularly, abandoning his earlier stringent approach, instead drawing caricatures of local characters in New York City and painting landscapes. Meanwhile, in Berlin, the 'Degenerate Art' exhibition of 1937 held by the Nazis included more than 200 of his drawings, many of which were later destroyed.

In June 1920, the first International Dada Fair was held in Berlin and Grosz helped to organise it. Among those who exhibited was a female artist named Hannah Höch (1889–1978).

Was part of the Dada movement, which was inspired by artists such as

MAKING A name for herself as a female artist among men, Hannah Höch was one of the first artists to create collages and photomontages, placing seemingly unrelated images together, helping to broaden the notion of what could be accepted as fine art.

Born in south-east Germany, Höch studied at the School of Applied Arts in Berlin, first taking glass design and then entering the graphics class of Emil Orlik (1870–1932). During that time, she began an intense relationship with the married artist Raoul Hausmann (1886–1971), who was a member of the Berlin Dada movement. After finishing her graphics course, Höch worked for the publisher Ullstein Verlag, designing dress and embroidery patterns for *Die Dame* (*The Lady*) and *Die Praktische Berlinerin* (*The Practical Berlin Woman*). This was generally considered an acceptable job for a woman, but when she joined the Berlin Dada group, she faced difficulties. Several of the other artists, including George Grosz, did not want her to exhibit at their International Fair in 1920, but Hausmann championed her and she contributed some photomontages. Made from pasted images cut from popular magazines and illustrated journals, her photomontages were often acerbic and satirical commentaries on contemporary society. She later claimed she had invented the technique of photomontage while on a Baltic holiday with Hausmann in 1918 after seeing images that some German soldiers were sending home, in which they had glued cut-out photographs of their heads onto pictures of musketeers. There may be some truth in this, but Höch had already been creating collages with embroidery and lace since 1916 when she worked for Ullstein Verlag.

In challenging the status of women through participating in a masculine world, Höch became close to the artist Kurt Schwitters (1887–1948), later recalling that he was one of the few male artists she knew who was willing to take a woman seriously as a colleague. In 1918, she wrote a manifesto on modern embroidery, encouraging Weimar women to pursue the 'spirit' of their generation and to 'develop a feeling for abstract forms' through their work.

She and Hausmann separated in 1922, and towards the end of the 1920s she left the Dada group. Höch moved to the Netherlands, where she began a relationship with the female writer Til Brugman and made friends with other artists, including Piet Mondrian (1872–1944), Tristan Tzara (1896–1963) and László Moholy-Nagy (1895–1946). She was particularly influenced by the De Stijl movement, and despite their different nationalities and styles of art, Höch and Mondrian became great friends.

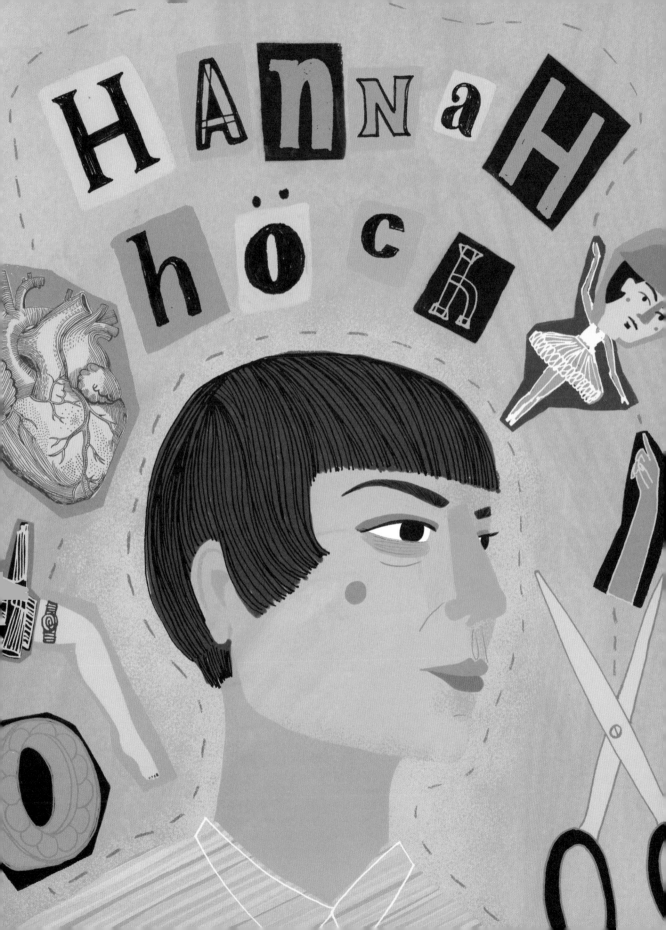

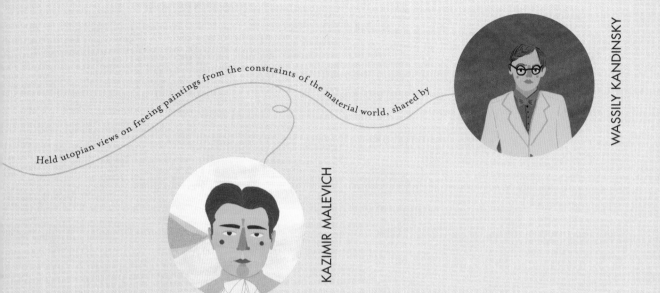

Held utopian views on freeing paintings from the constraints of the material world, shared by

WASSILY KANDINSKY

KAZIMIR MALEVICH

AN INNOVATOR of abstract art, Piet Mondrian was fascinated by theosophy, a religious philosophy that, among other things, advocates a spiritual reality beyond the physical world. Through balance and harmony, concentrating on the essentials, he profoundly affected fine and graphic art, fashion design and Modernist architecture.

Mondrian grew up in the Netherlands. His father, a local headmaster, was an enthusiastic amateur artist, and his uncle, Frits Mondriaan (1853–1932), was a professional artist who taught his nephew to paint. After studying at the Rijksakademie van Beeldende Kunsten in Amsterdam, Mondrian began painting local landscapes, often blending aspects of Symbolism, Impressionism and Neo-Impressionism. In 1911, he saw an exhibition of Cubist works by Pablo Picasso and Georges Braque (1882–1963), and decided to move to Paris. Once there, he fused elements of Cubism, Pointillism and Fauvism, reducing his colours and shapes.

During a visit to the Netherlands in 1914, the First World War broke out, so Mondrian remained there, gradually reducing all elements of his paintings until, by 1917, he was working only with straight horizontal and vertical black lines, with flat areas of primary colours, grey and white, all applied with smooth paint to achieve a perfect balance that would connect with and express the spiritual order of the world. He called this approach Neo-Plasticism after his translation of the Dutch phrase 'nieuwe beelding', which also means 'new form' or 'new image'. That same year, the painter and critic Theo van Doesburg (1883–1931) invited him and some others to write about their aesthetic theories in his new journal De Stijl (The Style). The term 'De Stijl' was also used to describe the art and design group that expanded to include architects, too. Van Doesburg thought of De Stijl a few years earlier when he had reviewed Mondrian's early abstract paintings in an exhibition in 1915. He contacted Mondrian directly and they became friends. Mondrian's essay 'Neo-Plasticism in Pictorial Art' was published in instalments in the De Stijl journal, attracting great interest among artists, designers and architects. At the beginning of the Second World War, after spending two years in London, Mondrian moved to New York City, where he exhibited with American abstract artists and continued to publish essays about Neo-Plasticism. His late style evolved, reflecting the architecture and boogie-woogie music he enjoyed.

For years, Mondrian's harmonious grids, lines and contrasting forms and colours fascinated Bridget Riley (b.1931). As well as making many careful studies of some of his paintings, she co-curated an exhibition of his work in London in 1996.

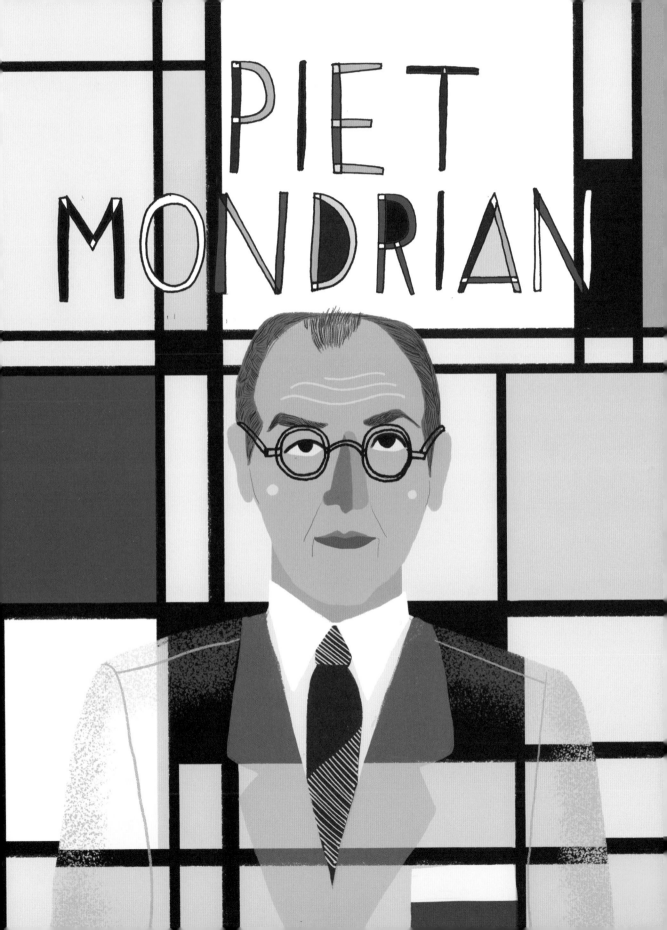

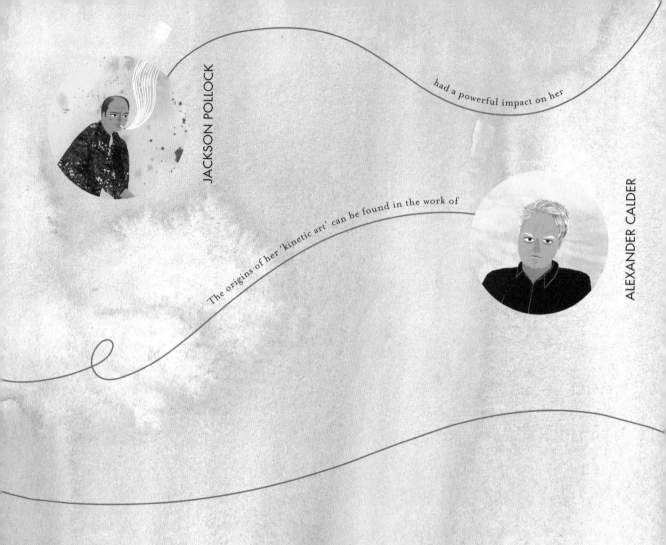

JACKSON POLLOCK

had a powerful impact on her

The origins of her 'kinetic art' can be found in the work of

ALEXANDER CALDER

FOLLOWING THE ideas of Georges Seurat (1859–91), Bridget Riley became fascinated by Pointillism as an art student and began to experiment with colour placement.

The idea that new colours seem to appear where they are not actually present, by juxtaposing colours in lines or shapes, inspired Riley initially to paint with only black and white to generate optical effects in viewers' eyes. She applied smooth paint in geometric abstract patterns, creating illusions of colour and motion, which became some of the best-known works of Op art. That term was first used by *Time* magazine in 1964 as a blend of the word 'optical' and Pop art. The following year, an exhibition at the Museum of Modern Art in New York titled 'The Responsive

Eye' featured works by several artists whose painted images appeared to move or change. Riley was among the artists exhibiting, and one of her paintings was used for the catalogue cover.

Riley lived in London until the age of seven, when she moved with her family to Lincolnshire. At the start of the Second World War, her father was conscripted, so Riley, her mother and her sister stayed with an aunt in Cornwall. The aunt had previously studied at Goldsmiths College in London, and after the war, Riley enrolled there and then attended the Royal College of Art. In 1955, her father was nearly killed in a car accident. Riley helped to nurse him for a year and had a nervous breakdown with the stress. From 1957, she taught art part-time at a girls' school in

Her work Painting with Verticals came from her close study of

Harrow and worked as a commercial illustrator at the advertising agency J. Walter Thompson.

In 1958, she saw a Jackson Pollock exhibition in London, which made a powerful impact on her, and the following year, she met painter and teacher Maurice de Sausmarez (1915–69), with whom she had an intense relationship. In the summer of 1960, they travelled to Italy and visited the Venice Biennale with its large exhibition of Futurist art. On her return, Riley taught part-time at Hornsey College of Art, then at Croydon School of Art while continuing with her part-time job at J. Walter Thompson. During that time, she began producing Op art paintings in black and white, and had her first solo show in London in the spring of 1962. The following year, she won

a prize in the open section of the John Moore's Liverpool exhibition and was awarded the AICA Critic's Prize in London. In 1967, she began exploring colour once more, and after visiting Egypt in the 1980s, she adopted what she called her 'Egyptian palette' of blues, golds and other vivid colours, while simplifying her compositions.

In 1968, eight years after visiting the Venice Biennale with Sausmarez, Riley was among nine artists representing the UK there, and she became the first female artist to win its Grand Prize for Painting. One of the other nine British artists was Ben Nicholson (1894–1982). It was the third time he had represented the UK at the Biennale.

BEN

NICHOLSON

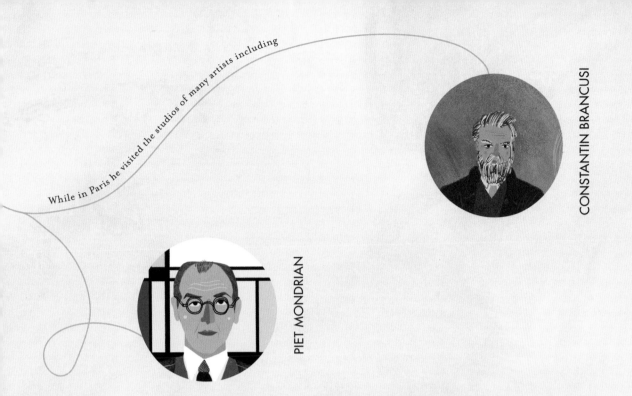

While in Paris he visited the studios of many artists including

CONSTANTIN BRANCUSI

PIET MONDRIAN

INSPIRED BY modern art styles including Cubism and Constructivism, Ben Nicholson produced paintings and reliefs, becoming an important figure in British Modernism. As a child of ten, one of his drawings was chosen by the playwright J.M. Barrie for the poster of *Peter Pan*.

The son of artists, Nicholson briefly attended the Slade School of Fine Art in London. From 1911 to 1914, he travelled around Europe, and was then exempted from military service during the First World War because of his severe asthma. He had an operation on his tonsils in New York in 1917, and painted conventional landscapes and still lifes in the UK in 1918. However, during a trip to Paris in 1921, he became inspired by Cubism, making his first semi-abstract paintings; after he joined the avant-garde Seven and Five Society, his paintings became completely abstract.

In the late 1920s, along with the sculptors Barbara Hepworth (1903–75) and Henry Moore (1898–1986), Nicholson stayed in St Ives in Cornwall, where he painted in a naïve style. In 1933, he and Hepworth made frequent trips to Paris where they joined the artists' association Abstraction-Création. While in Paris, they also visited the studios of Piet Mondrian, Georges Braque, Constantin Brâncuşi (1876–1957) and other contemporary artists. All helped him shape his ideas about reducing elements

in his work, but he was especially inspired by Mondrian. Soon after meeting him, Nicholson began carving low reliefs of circles and rectangles in wood and synthetic board, which he painted white, demonstrating his admiration of Cubism and Neo-Plasticism. By then he was living in London, and so when Mondrian arrived there in 1938 for a couple of years, he and Nicholson spent time together.

Nicholson edited *Circle*, a publication on Constructivist art, and joined an avant-garde artists' group called Unit One. Shortly after the outbreak of the Second World War, he left London for St Ives once again. There, he began to discard his severe rectilinear approach, drawing inspiration from his Cornish surroundings and also producing semi-abstract still lifes. In 1943, he joined the St Ives Society of Artists and was soon awarded prestigious accolades. For example, in 1952 he won first prize at the Carnegie International art exhibition in Pittsburgh and the Ulisse Prize at the Venice Biennale two years later. In 1955, he was given the Governor of Tokyo Award, and in 1956 the Guggenheim International Award. In 1968, he was awarded the British Order of Merit.

When they first met, Nicholson and Hepworth were both married to other people, but after their respective divorces, in 1938, they wed.

EXPLORING THE natural world and the idea of solidity and space through smooth, rounded forms, Barbara Hepworth created works that range from small to monumental. After growing up in Yorkshire, England, and living and working in Cornwall for more than thirty years, she was especially connected to her surrounding landscapes.

Hepworth won prizes for music at school and was awarded a scholarship to Leeds School of Art, where she met Henry Moore, who became both a friend and rival. At the age of eighteen, she won a place at the Royal College of Art in London, and after that she spent two years in Italy. Fascinated by Italian art, and especially by traditional techniques and skills, she began utilising the then little-used practice of direct carving, or working without preparatory sketches or models. After marrying her second husband, Ben Nicholson, in the 1930s, her sleek, curving work became increasingly abstract, and she was one of the first artists to introduce holes, or 'piercings' into her sculpture, creating light, lace-like effects.

Hepworth's career spanned five decades. While married to Nicholson, she worked closely with him, and while in Paris together, they visited the studios of Pablo Picasso, Jean Arp (1886–1966) and Sophie Taeuber-Arp (1889–1943), among others. They became part of an international network of abstract artists. With a son from her first marriage and triplets from her second, Hepworth moved to St Ives in Cornwall when war broke out in 1939. A decade later, she acquired Trewyn Studio from where she lived and worked for the rest of her life. Having worked predominantly with wood, in the mid-1950s, she began producing pieces using metal, such as brass and copper.

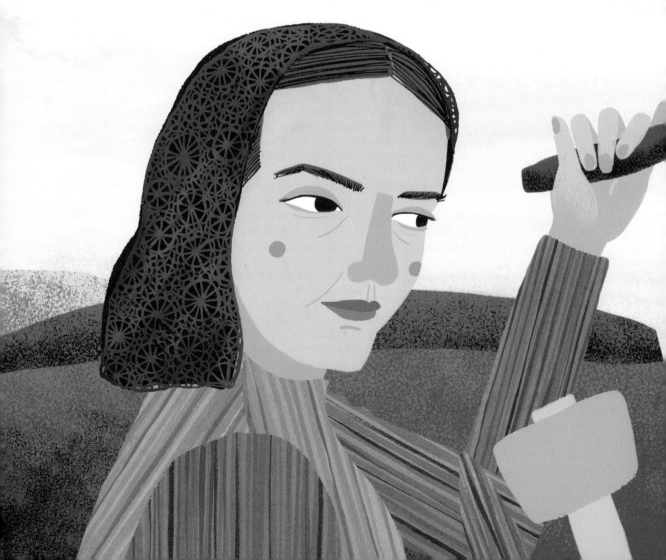

Although her work expresses organic forms and abstraction, Hepworth particularly explored relationships, including those within families, between figures and the landscape, between colour and texture, and between music and art. She often worked in collaboration with other artists and boldly explored unusual ways of working as well as innovative materials, themes and subjects. Despite working in a largely male-dominated world, she was asked to represent the UK at the Venice Biennale in 1950 and won first prize at the São Paulo Biennial in 1959. In 1965, a retrospective of her work was held at Kröller-Müller Museum in the Netherlands.

Through her innovative ideas and methods, Hepworth influenced countless artists and designers. In turn, for her, the most influential artist was Picasso, whom she met at his Paris studio in 1931.

In Paris with Nicholson, she visited

SOPHIE TAEUBER-ARP

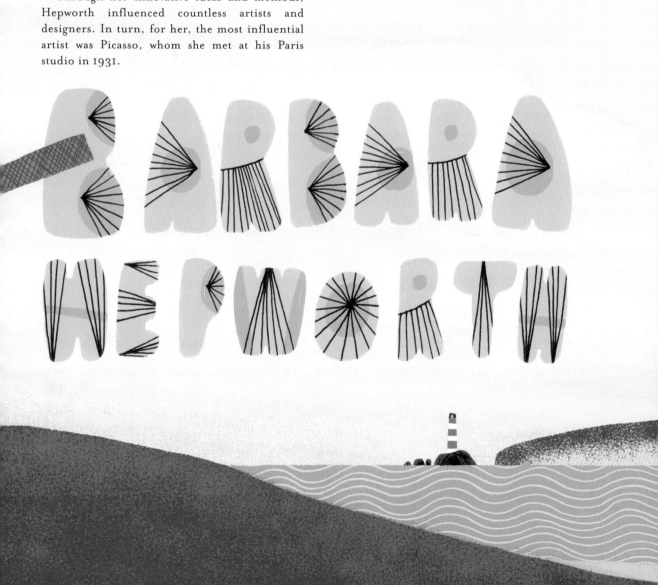

Was inspired by the work of Paul Gauguin, as was

AMONG A handful of artists known simply by one name, Picasso completely changed the history of art. He was born in Malaga, Spain, and his artistic genius shone from childhood. Overall, he produced more than 20,000 diverse works of art, including drawings, paintings, prints, sculptures and ceramics. His achievements brought him widespread recognition and prosperity.

The son of a painter and art teacher, at the age of thirteen Picasso was accepted at an art school in Barcelona, where he completed in a day the entrance exam that took older students more than a month. Five years later, he moved to Paris. After a friend committed suicide, he began to paint elongated subjects, echoing the artist El Greco (1541–1614), in shades of blue, which later became known as his Blue Period. In 1904, he progressed to his Rose Period with warmer, pinker colours. Finding inspiration everywhere, from Iberian sculptures to children's toys and drawings, from the Impressionists to African masks, he experimented untiringly. In 1907, he saw a retrospective of Paul Cézanne (1839–1906) and began to explore ways of representing three dimensions on two-dimensional surfaces. That year, he painted *Les Demoiselles d'Avignon*, which changed everything that had been valued in painting until then, and led to the development of Cubism. For some years, Picasso worked with Georges Braque, painting subjects from several viewpoints at once. This was Cubism, which challenged the principles of perspective that had been practised since the Renaissance.

Continuing to work incessantly, Picasso designed costumes and scenery for ballets, he became involved in the Surrealist movement, and briefly recreated his own form of Neoclassicism, painting curving, monumental figures. As well as paintings, he experimented with collages, etchings, sculpture and ceramics. In 1937, during the Spanish Civil War, the Spanish government asked him to paint something for their national pavilion at the Paris Exposition Universelle. Expecting him to glorify Spain, they were horrified at his huge painting depicting the effects of the bombing of the Basque town of Guernica. In black, grey and white, the distorted images show the devastation, both physical and emotional. For the rest of his life, Picasso continued to experiment, shock and surprise with his innovative ideas and materials.

In 1906, when Amedeo Modigliani (1884–1920) first moved to Paris, he settled in Le Bateau-Lavoir, Montmartre, where Picasso had a studio. Unusually for the time, both appreciated African art and they became friends. Picasso admired Modigliani's wardrobe and bought several of his paintings, although he did not particularly rate them, and Modigliani once admitted that he recognised Picasso's genius but that artistic talent was no excuse for dressing poorly.

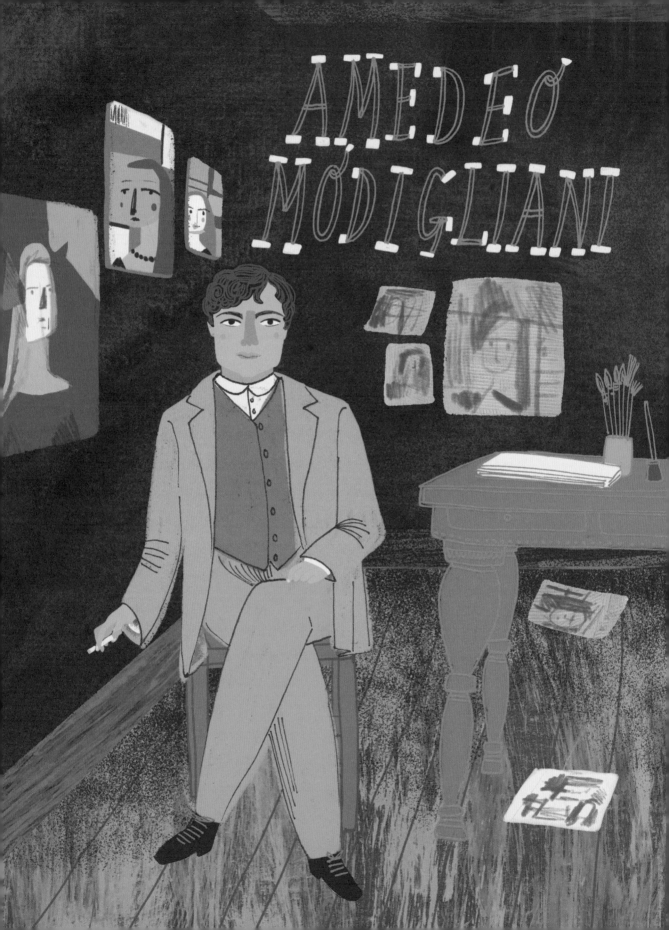

HENRI DE TOULOUSE-LAUTREC

inspired him to move to Paris

While in Paris he became good friends with

MAURICE UTRILLO

THE FOURTH child of an Italian Jewish family from Livorno in Tuscany, Amedeo Modigliani was born just as his father's business collapsed. Growing up, he suffered with pleurisy and typhoid fever, but at the age of fifteen, he began to study in the studio of the Italian artist Guglielmo Micheli (1866–1926). However, he was diagnosed with tuberculosis two years later, and his mother took him on a tour of Italy to recuperate. Soon after, he settled in Florence and studied figure drawing at the Scuola Libera del Nudo. While there, he became especially inspired by the paintings of Duccio (active 1278–1319), Simone Martini (c.1284–1344) and Sandro Botticelli (c.1445–1510). Next, he lived in Lucca and studied sculpture, but he was not strong enough for the strenuous and time-consuming stone-carving process and soon left. In 1905, at the Venice Biennale, he discovered the work of Henri de Toulouse-Lautrec (1864–1901) and other modern French artists. He moved to Paris and set up a studio in Montmartre, where he socialised with various painters and sculptors, including Gino Severini (1883–1966), André Derain (1880–1954), Chaïm Soutine (1893–1943) and Maurice Utrillo (1883–1955). He developed an elongated style in both painting and sculpture, producing portraits of friends, and especially of his mistress Jeanne Hébuterne (1898–1920), an art student whom he had met in 1917 when she was aged nineteen and he was thirty-three.

Inspired in particular by Constantin Brâncuşi, Cubism, and ancient Egyptian and African art, Modigliani's languid figures and portraits are highly stylised and sinuous, comprising reduced elements with long necks and almond-shaped, blank eyes. However, his overtly sexual female nudes, with their confident poses, horrified viewers and his style cannot be categorised. At the start of the First World War, poor health and a scarcity of materials meant that Modigliani stopped making sculpture and concentrated solely on painting.

Perpetually penniless and frequently ill, he nonetheless lived a wild life of womanising and sexual debauchery, over-indulging in drugs and alcohol. A stylish dresser, he was impetuous and quarrelsome, loved art and the written word, and is said to have regularly recited poetry from memory and kept the poetic novel *Les Chants de Maldoror* (1869) by the Comte de Lautréamont in his pocket at all times. He also drew obsessively, often trading quick sketches of people in cafés for a few coins, a meal or a drink. One of the many artists he befriended was the Mexican painter Diego Rivera (1886–1957), who was in Paris in 1913. The two became good friends and Modigliani painted three portraits of Rivera.

DIEGO
RIVERA

JACKSON POLLOCK

discovered the expressive power of paint through the Mexican Muralists

AMEDEO MODIGLIANI

In 1914, he had his portrait painted by

A FOUNDER of the Mexican Muralist movement, Diego Rivera used Italian fresco painting techniques, blending aspects of modern European painting with elements of Mexico's pre-Columbian heritage, including a bright palette, flat shapes and a sense of naivety.

To avoid tensions caused by his father's role as co-editor of the newspaper *El Democrata*, when he was a child, Rivera's family moved from Guanajuato to Mexico City. By the age of ten, he had decided he wanted to go to art school rather than pursue a military career as his father wished. The following year, he began studying at the San Carlos Academy of Fine Arts, and while there, he also received instruction from the Mexican painter and writer 'Dr Atl', or Gerardo Murillo (1875–1964), who taught him about Mexican indigenous culture and crafts. Murillo also helped

Rivera to obtain a grant to travel to Europe, where he studied the work of El Greco, Diego Velázquez, Francisco de Goya (1746–1828) and Flemish masters in Madrid's Prado Museum. At the studio of the Spanish realist painter Eduardo Chicharro (1873–1949), Rivera met some of the leading figures of the Madrid avant garde.

In 1909, he travelled to Paris and Belgium with the writer Ramón del Valle-Inclán and met the Russian painter Angelina Beloff (1879–1969). They married that same year and returned to Mexico in 1910, at the start of the Mexican Revolution. Despite this, Rivera had his first exhibition and used the money he earned from it to return to Europe, where he discovered Cubism and the work of Paul Cézanne. However, a violent incident with the art critic Pierre Reverdy (1889–1960) ended his associations with Picasso,

From c.1917, he became inspired by the work of

PAUL CEZANNE

Georges Braque, Juan Gris (1887–1927) and Fernand Léger (1881–1955). It became known in artistic circles as 'l'affaire Rivera' after the two men argued at a dinner party and Rivera threw a punch. He later attempted to apologise, but Reverdy refused to shake his hand. Numerous witnesses took sides, mainly against Rivera.

In 1921, he returned to Mexico, leaving Beloff and another Russian artist with whom he had a baby daughter. After visiting various pre-Columbian archaeological sites in Mexico, he painted his first mural. He joined the Revolutionary Union of Technical Workers and the Mexican Communist Party, and began to promote his left-wing political beliefs through his art, which aroused considerable controversy.

In 1927, he visited the Soviet Union to celebrate the tenth anniversary of the October Revolution.

He spent nine months in Moscow teaching mural painting at the School of Fine Arts, but was then ordered to leave for his involvement in anti-Soviet politics. In 1929, he was expelled from the Mexican Communist Party. From 1930, he worked in the United States for four years, in California, New York, Detroit and Chicago.

Rivera had married his second wife, the model and novelist Guadalupe Marín, in 1922, and they were still married when the eighteen-year-old art student Frida Kahlo (1907–54) asked him for painting advice. Rivera and Kahlo married in 1929, when he was forty-two and she was twenty-two. He was tall and overweight; she was small and delicate. Her parents described the union as a 'marriage between an elephant and a dove'.

INFLUENCED BY traumatic health and personal problems as well as by her German-Mexican ancestry, Frida Kahlo is recognised for her colourful, introspective paintings. Although often classed as a Surrealist, she always denied it. She is also often categorised as a Magic Realist.

Born on the outskirts of Mexico City, Kahlo grew up in a strict household with five sisters. When she was six, she contracted polio and was bedridden for nine months; after her recovery, she walked with a limp. When she was eighteen, her school bus collided with a tram. Impaled by an iron handrail, she sustained multiple fractures and a crushed pelvis and spent nine months in hospital, bound in a plaster corset, then even longer at home in bed, never fully recovering. During her convalescence, her father introduced her to painting and to the writings of poets and philosophers such as Goethe, Friedrich Schiller and Arthur Schopenhauer. She began painting self-portraits and joined a group called the 'Cachuchas', who rebelled against everything conservative in Mexico. She also took drawing classes. In 1928, she joined the Mexican Communist Party and was introduced to Diego Rivera, whom she had met briefly in 1922. Even though he was married and more than twenty years older than her, they became passionately involved.

After they married, Kahlo began wearing traditional Tehuana costume and drew more closely on ideas from Mexican folk art. Rivera, however, had a violent temper and was unfaithful, which affected Kahlo's fragile health. She plunged into affairs with men and women, miscarried twice, had two abortions, an appendectomy and two gangrenous toes amputated. Although she was gaining recognition for her art, her emotional and physical problems penetrated every aspect of her life and art. In 1938, the founder of Surrealism, André Breton (1896–1966), hosted her first exhibition in Paris, and the following

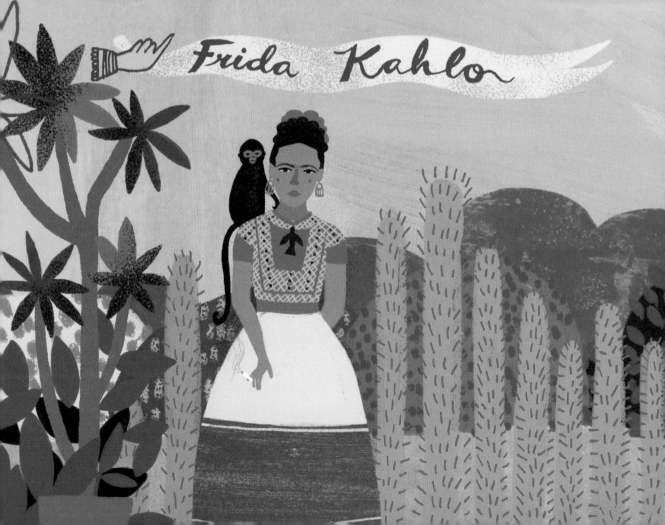

Frida Kahlo

year, she and Rivera divorced, only to remarry in 1940. Kahlo's health worsened, and in 1953, she was taken to her solo exhibition in an ambulance and carried to a four-poster bed that had been placed in the gallery.

Despite her own tragedies, in 1933, two years after they first met, twenty-six-year-old Kahlo wrote to forty-six-year-old American artist Georgia O'Keeffe (1887–1986) when O'Keeffe was hospitalised for a nervous breakdown and instructed by doctors not to paint for a year. Kahlo wrote: 'I would like to tell you everything that happened to me since the last time we saw each other, but most of them are sad and you mustn't know sad things now.'

On her trip to Paris in 1939, she met artists including

JOAN MIRO

WASSILY KANDINSKY

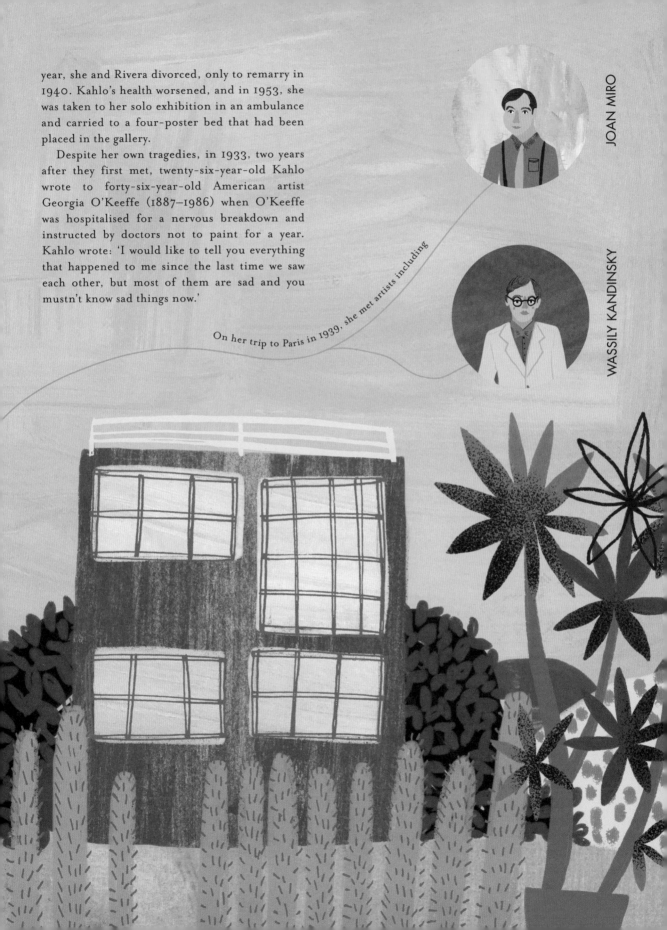

Was inspired by the work of

JUDY CHICAGO

AUGUSTE RODIN

Was a strong influence on

FROM HER childhood on a Wisconsin farm, Georgia O'Keeffe grew up to paint vast landscapes, dramatic skyscrapers, clouds, flowers and animal bones, and to sculpt curving abstract forms. Seeking to capture emotion and power through abstractions of the natural world, she is often referred to as the 'mother of American Modernism'.

Unusually for the time, O'Keeffe's family encouraged girls' education, and she studied at the Art Institute of Chicago, but left when she contracted typhoid fever. In 1907, she enrolled at the Art Students League of New York, where she learned the latest painting techniques from prominent artists including William Merritt Chase (1849–1916). She began working as a commercial illustrator and then taught art in Virginia, Texas and South Carolina, while also studying art intermittently. During this time, O'Keeffe was introduced to the principles of artists Arthur Wesley Dow (1857–1922) and Arthur Dove (1880–1946), who stressed the importance of individual interpretation.

In 1915, she sent some charcoal drawings to a friend in New York, who showed them to the photographer and art dealer Alfred Stieglitz (1864–1946). Without telling O'Keeffe, Stieglitz exhibited ten of the drawings at his 291 Gallery. When she found out, she confronted him, but gave him permission to continue showing them. Two years later, he presented her first solo show. Encouraged by Stieglitz, O'Keeffe moved to New York, where he found her a place to live and work and helped her financially. In 1924, after his divorce, they married. She began producing monumental paintings of flowers and New York skyscrapers. By 1927, she had become exceptionally successful: a major achievement for a female in the art world. From 1929, she began to spend time in New Mexico, inspired by what she called 'the faraway', which included the landscape and the local Navajo culture.

Never part of an art movement, O'Keeffe was one of the few artists to represent the real world at a time when most were focusing on abstract art or had abandoned painting altogether. She rendered meticulous close-ups that, through their proportions and scale, appeared abstract. She explained the reasoning behind her large flower paintings: 'Nobody really sees a flower – really – it is so small – we haven't time . . . So I said to myself – I'll paint what I see – but I'll paint it big and they will be surprised into taking time to look at it.'

Also known for his brightly coloured, semi-abstract paintings of objects, including flowers, Takashi Murakami (b.1962) creates a blend of references to Japanese pop culture and Japan's artistic heritage.

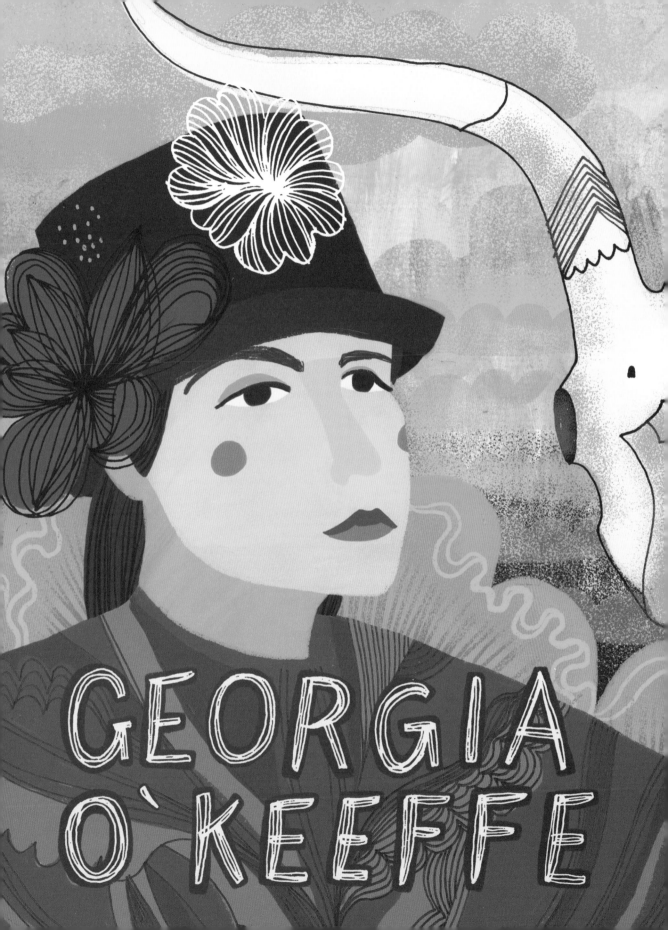

GEORGIA O'KEEFFE

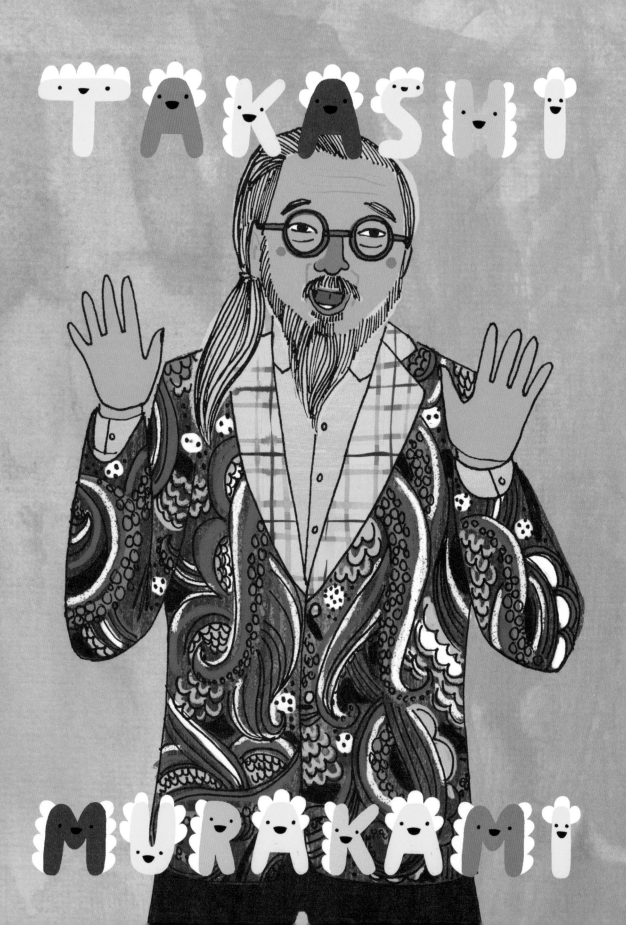

BOTH PRAISED and criticised for his brightly coloured artworks, including painting, sculpture, and animation, Takashi Murakami blurs distinctions between high and low art, questioning influences of the West and compelling viewers to confront contemporary culture. Overall, his work is based on his interest in the Japanese concept of kawaii (all things 'cute'), anime and manga.

Murakami titled his own art movement 'Superflat'. Admirers perceive his work as a form of early twenty-first-century Pop art and often call it Neo-Pop, while critics dismiss it as his ridiculing of modern Japan. Influenced by textile design and by the US presence in Japan after the Second World War, the art mixes traditional Japanese culture, modern European art and Japanese animation. In 1980, Murakami studied the formal Japanese style of Nihonga painting in Tokyo, remaining at university to take a master's degree and a doctorate. While there, he was taught by the German Conceptual artist Joseph Beuys (1921–86), who profoundly affected his approach. Beuys's dismissive attitude inspired Murakami's criticism of the Western art market, and his early cynical works reflect the difficult post-Second World War relationship between Japan and the United States. In 1994, Murakami visited New York City for a year on a fellowship and was inspired by the expressive art of Anselm Kiefer (b.1945) and the colourful kitsch work of Jeff Koons (b.1955). After returning to Japan, he simplified his style and began exhibiting across Europe and the United States. One of his developments was Mr DOB, a cheery, razor-toothed character based on anime and manga figures, which appears frequently in his art.

Murakami established the Hiropon Factory in 1996, the predecessor of his company Kaikai Kiki founded in 2001. Modelled on both traditional Japanese art workshops and the Factory owned by Andy Warhol (1928–87), Kaikai Kiki is an art business. There are two sites, in Tokyo and New York, each with trained assistants who create large-scale projects under Murakami's supervision. Besides producing and marketing Murakami's artwork, Kaikai Kiki promotes new artists, organises art fairs and collaborative projects, and develops animated videos and films. A collaboration with the fashion label Louis Vuitton helped Murakami move closer to his aim of eliminating distinctions between art and commerce. In 2008, he reworked Vuitton's established monogram print and sold it at the Brooklyn Museum rather than in fashion outlets. Another Japanese artist who has collaborated with Louis Vuitton is Yayoi Kusama (b.1929). Kusama designed an extensive collection, featuring her signature bold dots.

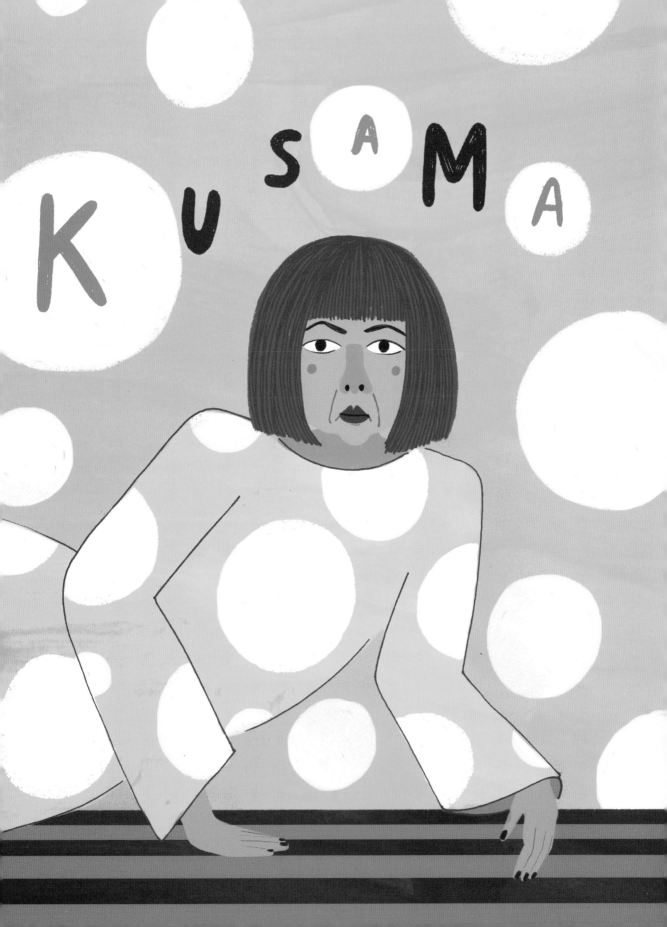

Moved to the United States after writing a letter of introduction to GEORGIA O'KEEFFE

In New York, she also socialised with artists including

AIMING TO provoke powerful feelings among viewers, Yayoi Kusama regularly works with mirrors and bright colours, creating repeating patterns of such things as dots and pumpkins. Utilising unusual materials, she paints and produces installations, filling large spaces to generate the greatest impact.

Born in Matsumoto in Japan in 1929, Kusama was sent to work in a military factory when she was thirteen years old, where she sewed parachutes for the Japanese army during the Second World War. After the war, she studied the formal style of Nihonga painting in Kyoto before moving to New York in the late 1950s, where she was inspired by Abstract Expressionism and socialised with artists including Donald Judd, Andy Warhol, Joseph Cornell (1903–72) and Claes Oldenburg (b.1929). After first painting with gouache, watercolour and

oils, Kusama began to experiment with sculpture and installation, exploring her identity as a female artist in a male-dominated society, as a Japanese artist in the Western art world, and as a victim of her own neuroses. She came to public attention when she organised a series of happenings in which naked people were painted with brightly coloured polka dots, which became the most prominent motif in her work. Calling the dots 'infinity nets', she explained that they derived directly from the hallucinations she had experienced since childhood. In fact, the earliest example of dots in her work was made when she was aged ten: a drawing of a woman wearing a dot-patterned kimono.

Since returning to Japan in 1973, Kusama has been involved with painting, drawing, collage, sculpture, performance, film, printmaking, installation, environmental art, literature,

EVA HESSE

ANDY WARHOL

fashion (including her collaboration with Louis Vuitton) and product design. Much of her work expresses her childhood memories and ideas about floating and being closed in. It features an extensive use of mirrors and lights, as she seeks to evoke elements of her hallucinations. Although Kusama is usually classed as a Conceptualist, she insists that her work cannot be labelled. Pumpkins for her are a form of self-portrait, and many of her installations are intentionally created for audience participation, so that viewers can immerse themselves in her experiences.

Kusama's ideas continue to flow, as she expresses dynamism, contradiction, unpredictability and colour in numerous variations. With exhibitions in galleries and museums all over the world, she was chosen in 2016 as one of the world's 100 most influential people by *Time* magazine. Also

in 2016, she received the Order of Culture, one of the highest honours bestowed by the Imperial Family in Japan. In 2017, the Yayoi Kusama Museum opened in Tokyo, founded with the aim of spreading and promoting her art. In 2016, Kusama was commissioned to illustrate Hans Christian Andersen's fairy tale *The Little Mermaid* (1839), for an edition published by the Louisiana Museum of Modern Art in Denmark. Two years later, the artist Marina Abramović (b.1946) was also commissioned by the same museum to illustrate *The Ugly Duckling* (1843), another tale by Hans Christian Andersen.

MAKING VIEWERS an important part of her performances, Marina Abramović focuses on the limitations of the human body, the possibilities of the mind, and connections between artist and viewers, often exploring these through such things as pain and blood.

Until the age of six, Abramović was brought up in Belgrade, former Yugoslavia, by her religious maternal grandmother. Then, in 1952, her brother was born and she began living with her parents. However, her mother's repressive behaviour meant that, from an early age, Abramović found solace in drawing and painting. She studied at the Academy of Fine Arts in Belgrade and at the Academy of Fine Arts in Zagreb. She soon abandoned painting and drawing, preferring to use her body as her art; she was especially inspired after seeing the happenings of Joseph Beuys. In 1973, she presented her first performances while teaching art in Serbia. Two years later, she travelled to Amsterdam to participate in an international gathering for performance artists and met the German artist Frank Uwe Laysiepen, known as Ulay (b.1943). She returned to Belgrade, divorced her husband of five years and for the first time moved out of her family home, returning to Amsterdam and Ulay. They created several works together, wrote a manifesto about their artistic practice and travelled through Europe. They then settled in Amsterdam before travelling once again, this time to Australia, where they lived with an Aboriginal tribe for nine months. Later, they travelled to India and then China, putting on their performances wherever they went. Since 1990, Abramović has worked as a visiting professor in Paris, Berlin, Hamburg and Brunswick.

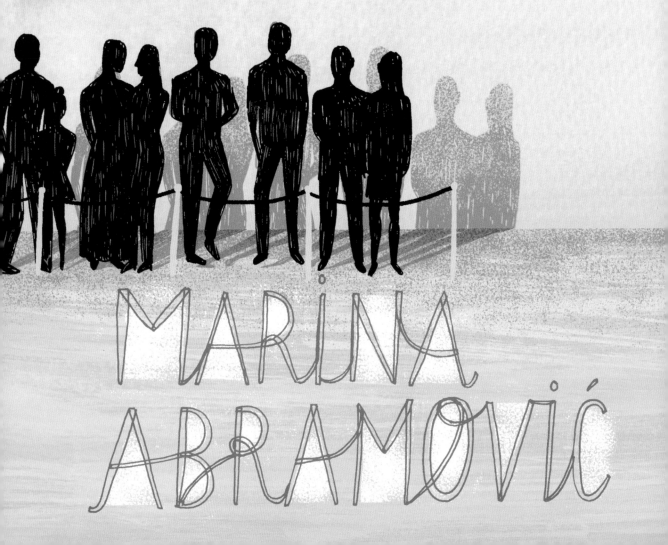

MARINA ABRAMOVIĆ

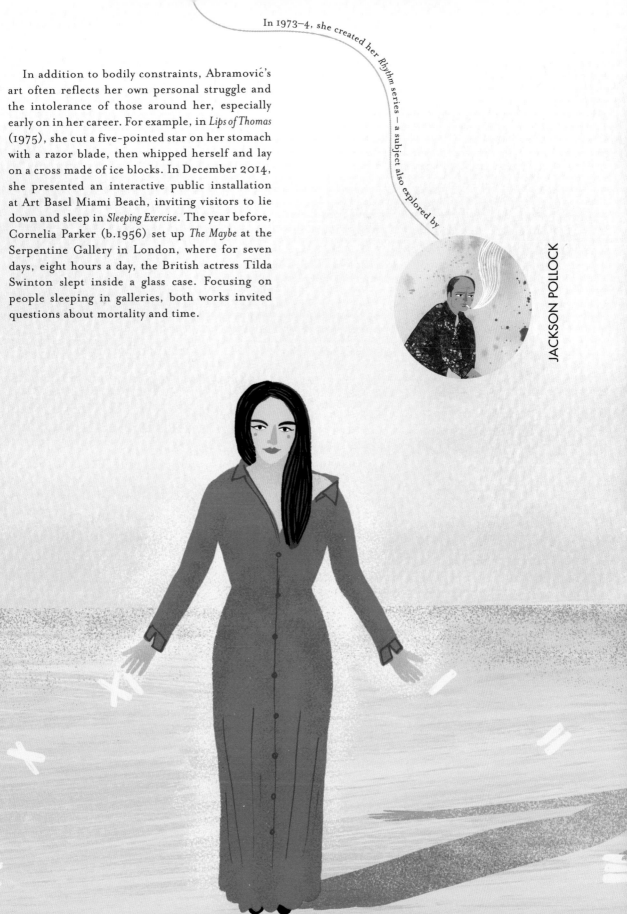

In 1973–4, she created her *Rhythm* series — a subject also explored by

In addition to bodily constraints, Abramović's art often reflects her own personal struggle and the intolerance of those around her, especially early on in her career. For example, in *Lips of Thomas* (1975), she cut a five-pointed star on her stomach with a razor blade, then whipped herself and lay on a cross made of ice blocks. In December 2014, she presented an interactive public installation at Art Basel Miami Beach, inviting visitors to lie down and sleep in *Sleeping Exercise*. The year before, Cornelia Parker (b.1956) set up *The Maybe* at the Serpentine Gallery in London, where for seven days, eight hours a day, the British actress Tilda Swinton slept inside a glass case. Focusing on people sleeping in galleries, both works invited questions about mortality and time.

JACKSON POLLOCK

KNOWN FOR her large-scale, often site-specific installations, Cornelia Parker frequently explores the fragility of life, how materials perform, and transformations — whether violent and precipitous, or slow and gradual — including her personal consideration of both natural changes and those wrought by humans.

Shortlisted for the prestigious Turner Prize in 1997, Parker was elected to the Royal Academy of Arts and appointed an Officer of the Order of the British Empire in 2010. She works with a wide range of materials and has collaborated with respected and disparate institutions in Britain.

Born in north-west England, Parker studied art in Gloucestershire and Wolverhampton, and has since received several honorary doctorates. Her work is held in numerous international collections, and she participates in many worldwide exhibitions. In 2015, she produced *Magna Carta (An Embroidery)*: a 13-metre (42½ ft) long embroidery, stitched by more than 200 individuals. That year, she also made an installation for St Pancras International station in London. *One More Time* was a working, oversized replica of the station's clock, but in black to contrast with the original clock's white face. In 2016, Parker became the first woman to be given the Roof Garden Commission at the Metropolitan Museum of Art, New York. *Transitional Object (PsychoBarn)* was a large-scale sculpture based on American architecture, inspired by a painting by Edward Hopper (1882–1967), a film by Alfred Hitchcock and a red barn. In 2017, she was the UK's official election artist for the general election.

Parker is best known for large-scale installations, such as *Cold Dark Matter: An Exploded View* (1991), which comprised a garden shed that had been blown up by the British Army. She suspended the fragments as if the explosion itself were caught in time. In the centre, she placed a

light that threw dramatic shadows of the fragments onto the walls of the surrounding room. Six years later, for the Turner Prize exhibition, she created *Mass (Colder Darker Matter)*: the charred remains of a church that had been struck by lightning in Texas, also suspended from the gallery ceiling.

Often exploring things that are beyond our control, Parker continues to investigate processes and resulting changes, including contrasts of predictability and instability, and volatility and calmness, presenting viewers with imagery and experiences that evoke contemplation and consideration. In 2003, she wrapped Auguste Rodin's (1840–1917) sculpture *The Kiss* (1901–04) in a mile of string and renamed it *The Distance (A Kiss with Added String)*.

MARCEL DUCHAMP

Was 'inspired by other artists who deal with the fragment and things that are immaterial', such as

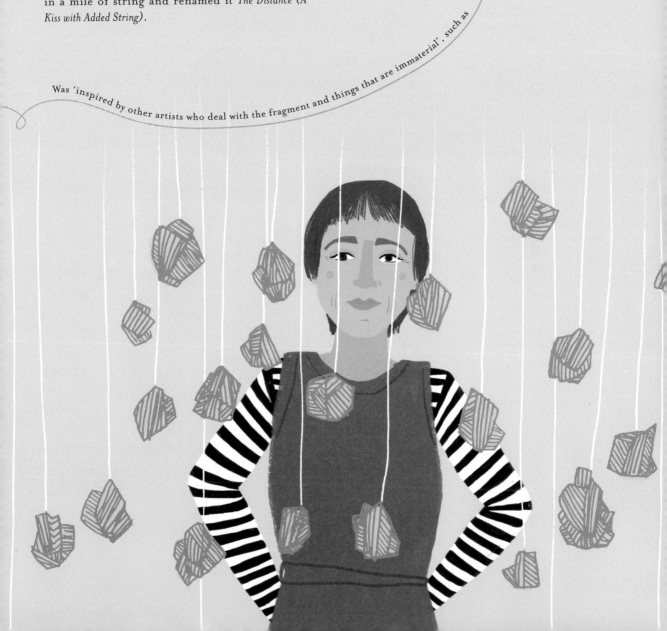

AUGUSTE RODIN

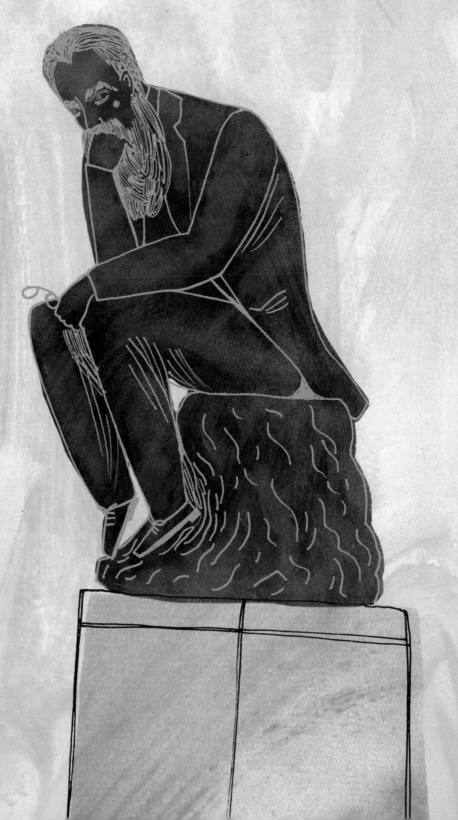

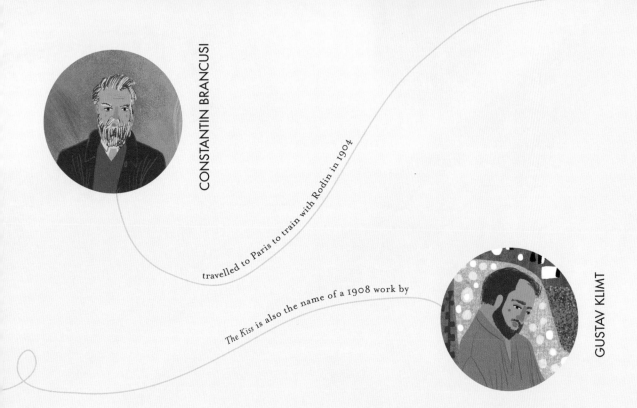

CONSTANTIN BRANCUSI

travelled to Paris to train with Rodin in 1904

The Kiss is also the name of a 1908 work by

GUSTAV KLIMT

REJECTED AT first by official art academies, Auguste Rodin spent years working as an ornamental sculptor before scandal catapulted him to fame. By the time of his death, he was being compared to Michelangelo Buonarroti (1475–1564), and his reputation as the father of modern sculpture remains unchanged. He created lifelike, natural-looking marble and bronze figures often with an illusion of movement that contrasted with idealistic sculpture traditions. His figures were in everyday poses with natural gestures, often with rough surfaces that expressed spontaneity.

From a poor Parisian family, Rodin enrolled at the École Impériale Spéciale de Dessin et de Mathématiques, which trained boys in the decorative arts, and three years later applied to the École des Beaux-Arts. He passed the drawing exam but failed in sculpture three times, so instead worked as an assistant to the sculptor Albert-Ernest Carrier-Belleuse (1824–87).

When the Franco-Prussian War broke out in 1870, Rodin served as an officer in the army. In 1871, he followed Carrier-Belleuse to Brussels, and in 1876 visited Florence to study the work of Michelangelo. On his return to Brussels, he created a life-size sculpture of a young officer, which he called *The Age of Bronze*. It was accepted for

the Paris Salon in 1877, but doubts arose about its authenticity and he was accused of casting directly from the model's body. A scandal erupted, but Rodin was proved innocent. He was commissioned to create a monumental bronze doorway for a future museum; he called his designs *The Gates of Hell*, but the museum was cancelled. In 1889, Paris held a centennial celebration of the French Revolution, and Rodin showed thirty-six works, almost all influenced by *The Gates of Hell*. Next, he was commissioned to create a work to commemorate the Hundred Years' War between England and France. *The Burghers of Calais* (1884–89) was almost rejected for its depiction of the city's heroes as victims. Two years later, Rodin received another commission: to create a memorial for the poet Honoré de Balzac. Although he worked on it for seven years, the result was rejected. Despite this, by 1899, Rodin was internationally renowned, with a large studio and assistants.

From 1884 to 1898, Rodin had a passionate relationship with Camille Claudel (1864–1943), a young sculptor who worked as his assistant. During their time together, Rodin made several erotic sculptures of loving couples, but Claudel left him when it became clear that he would not leave his girlfriend.

camille

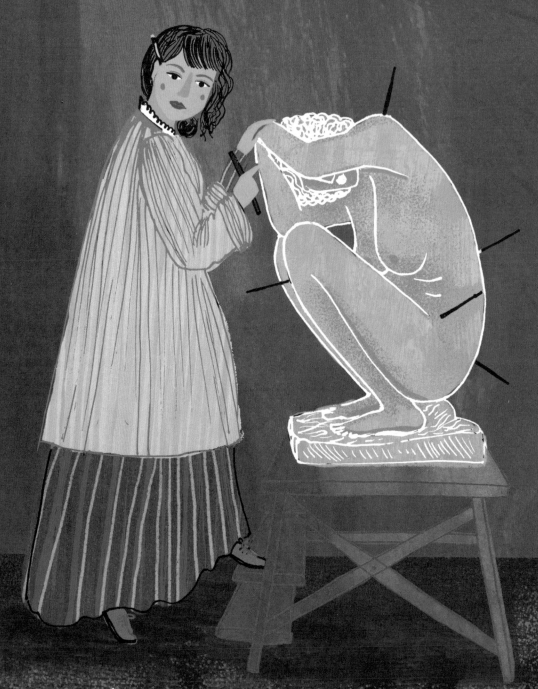

claudel

FASCINATED BY the human figure and methods that can be used to portray emotion, Camille Claudel conveyed characteristics such as innocence, wisdom and love through her sculpture, using skills she learned from Alfred Boucher (1850–1934) and Rodin.

Claudel began working with clay when she was twelve years old, and some of her early work attracted the attention of Boucher, who advised her father to encourage her artistic career. Her mother disagreed, but Claudel later joined the Académie Colarossi, one of the few institutions of the time that accepted females. Boucher became her mentor. She made a bust of him and he produced *Camille Claudel Lisant* (1882), a sculpture of a delicate, contemplative young woman reading. At the age of eighteen, Claudel rented a workshop with several other young female sculptors, including Jessie Lipscomb (1861–1952), Amy Singer (dates unknown) and Emily Fawcett (1847–1929). Boucher advised them all, but after winning the Grand Prix du Salon in 1881, he moved to Florence and asked Rodin to take over the instruction of his students, which was how, in around 1884, Claudel began working with Rodin as his assistant and they embarked on their intense affair. Claudel became Rodin's muse and lover, but as he would never end his relationship with Rose Beuret (1844–1917), Claudel was constantly jealous, which led to paranoia. Her parents were scandalised by the relationship and they made her leave the family home. However, within a short time, and after having an abortion in 1892, she ended the intimate side of her relationship with Rodin. However, they continued to see each other until 1898, when she moved away completely.

Meanwhile, with the sinuous curves of Art Nouveau and Japanese *ukiyo-e* prints, Claudel's own work was becoming popular. In 1886, her sculpture *Shakuntala* won a prize at the Salon, and her experiments with materials and combinations of marble and bronze were innovative, which attracted a number of wealthy patrons. Yet from 1905, her mental health began to deteriorate: she often destroyed work and was convinced that everyone was against her. She locked herself in her studio, installed traps behind doors and only spoke to visitors through shutters. After her father died in 1913, her mother and siblings had her committed to an asylum.

About six years after Claudel left Rodin's studio, another sculptor moved in, also as an assistant. Constantin Brâncuşi only stayed for a month, however. When he left, he declared: 'No other tree can grow in the shadow of a great oak.'

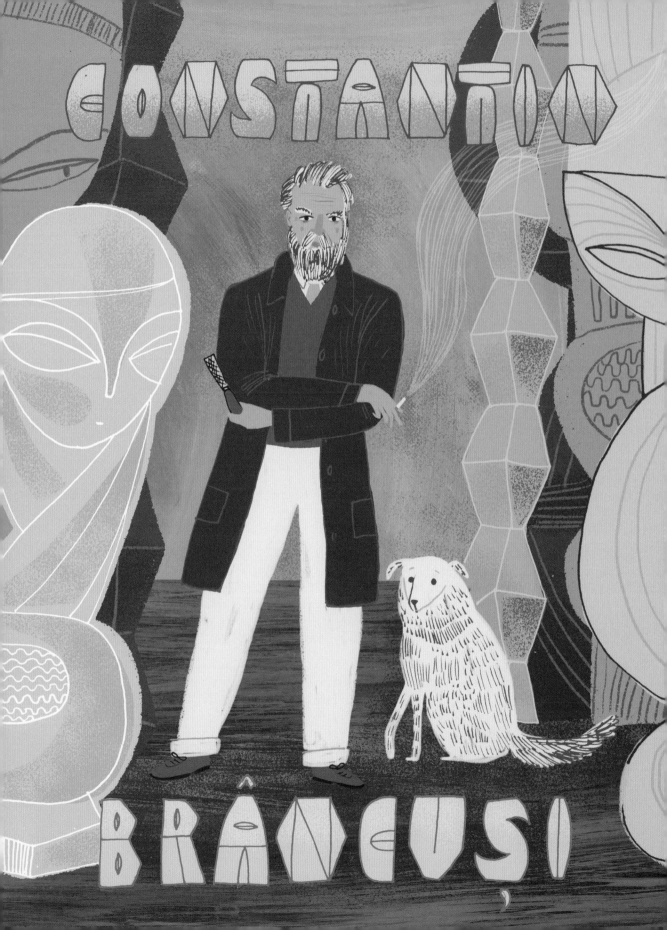

CONSTANTIN
BRÂNCUȘI

His first solo show in New York was presented by Alfred Stieglitz, husband of

GEORGIA O'KEEFFE

BEFORE HE became a great pioneer of Modernist sculpture during the first half of the twentieth century, Constantin Brâncuşi grew up in a Romanian village where woodcarving and other folk craft traditions influenced him.

When he was eleven years old, Brâncuşi left home; two years later, he began studying part-time at the School of Arts and Crafts in Craiova, while also working in various jobs to earn money. From 1894, he studied at the school full-time for four years, graduating with honours, and he then studied life sculpture in Bucharest until 1902, where he won several awards. Two years later, he travelled to Paris, mostly on foot, and once there, he nurtured the notion of his exotic heritage by wearing Romanian peasant clothing and hand-carving his own furniture. From 1905, he trained in sculpture and modelling at the École des Beaux-Arts, and after that began working as a studio assistant to Auguste Rodin. He left after only a month, though, saying that he could never shine while in the presence of such a great artist.

Influenced by Romanian folklore and 'primitive' cultures, Brâncuşi began to form his own style, creating smoothly contoured sculptures in marble and other stones, bronze and other metals, and wood, often producing several alternative versions of one theme. Many of his sculptures are deceptively simple, as his reduced forms were intended to reveal hidden truths. Whereas most sculptors used a more mechanical method, creating preparatory models and maquettes, Brâncuşi preferred the rarely used technique of direct carving.

At the ground-breaking Armory Show in New York in 1913, which exhibited avant-garde European and American art, five of Brâncuşi's works were shown. The following year, he had his first solo show, also in New York. His smooth, stylised forms, with their lack of realism or detail, and his ideas, such as making his sculpture's base as important as the work itself, aroused criticism. Although Rodin had showed that sculpture traditions could be broken, Brâncuşi's work seemed a step too far. He sought to create sculpture that conveyed the essence of a subject, with no distractions or superfluities. Many described his work as abstract, but he always maintained that he represented reality. He also paid close attention to whatever materials he was using, polishing his metal works for days to achieve a fine sheen, for example. A contemporary artist who similarly sought to convey shining, gleaming effects, only with paint rather than sculpture, was Fernand Léger, who became one of Brâncuşi's closest friends in Paris.

ALTHOUGH KNOWN as a Cubist, Fernand Léger regularly changed his painting style, varying from figurative to abstract. He took inspiration from numerous sources and worked in a range of media, including paint, ceramics, print, film and glass. His Cubist paintings are distinguished by their cylindrical, machine-like forms, created through strongly contrasting tones and bold colours, expressing his view of the modern urban environment.

Léger was initially apprenticed to an architect. After finishing his compulsory military service in 1903, he applied to study at the École des Beaux-Arts in Paris, but was rejected; instead he attended the École des Arts Décoratifs, which emphasised design, and the open-minded Académie Julian. Meanwhile, he made his living by producing architectural drawings and retouching photographs. He began to paint in an Impressionistic style, but after visiting the Cézanne retrospective at the Salon d'Automne in 1907, his art changed completely.

With an emphasis on cylindrical forms, Léger's first Cubist work was nicknamed 'Tubism' by critics. In 1911, the hanging committee of the Salon des Indépendants grouped his paintings with those of other artists under the label Cubism. The following year, he exhibited with several of the same artists and others, including Jean Metzinger (1883–1956), Albert Gleizes (1881–1953), Francis Picabia (1879–1953) and the Duchamp brothers – Jacques Villon (1875–1963), Raymond Duchamp-Villon (1876–1918) and Marcel Duchamp (1887–1968) – calling themselves the Puteaux Group. They also became known as the Section d'Or (Golden Section). From that time until 1914, Léger's paintings became increasingly abstract, featuring more tubular, conical and cuboid forms. At the start of the First World War, he was conscripted to the French army, but was

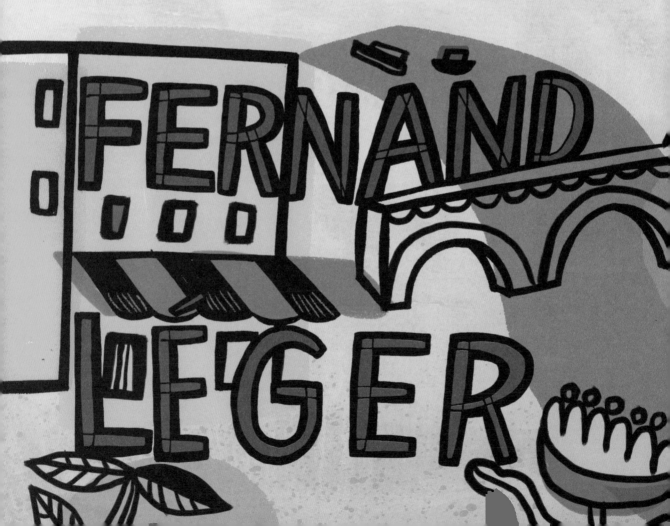

sent home in 1916 after being gassed at Verdun. While at the Front, he made drawings of his fellow soldiers, and on his return to Paris, he focused less on his earlier abstractions and more on figures. In 1931, he visited New York City and Chicago, and four years later, New York's Museum of Modern Art presented an exhibition of his work.

In 1909, Léger had moved to the Montparnasse area of Paris, taking a studio at La Ruche, where he befriended other artists, including Alexander Archipenko (1887–1964), Jacques Lipchitz (1891–1973), Marc Chagall (1887–1985), Robert Delaunay (1885–1941) and Sonia Delaunay-Terk (1885–1979). In around 1913, he, Delaunay and Delaunay-Terk became particularly influenced by the colour theories of the French chemist Michel Eugène Chevreul, especially his book *On the Law of Simultaneous Contrast of Colours* (1839), which they debated often and explored through their art.

ALEXANDER CALDER

FOR ALMOST seventy years, the artist and designer Sonia Delaunay-Terk painted; designed textiles, clothing and stage sets; ran shops and collaborated with poets. She and her husband Robert Delaunay pioneered the movement Simultanism. Their work was also labelled Orphism by their friend, the art critic and poet Guillaume Apollinaire (1880–1918).

Ukrainian-born Delaunay-Terk later drew on her childhood memories of her native country, especially the colourful costumes of peasant weddings. When she was seven years old, she went to live with her prosperous aunt and uncle in St Petersburg, where she experienced a privileged and cultured upbringing, and from the age of eighteen, she studied painting in Karlsruhe, Germany. At twenty-three, she moved to Paris to study, where she was inspired by Post-Impressionism and Fauvism. During her first year in Paris, Delaunay-Terk met and married Wilhelm

Uhde (1874–1947), an art dealer, collector and critic. The marriage enabled her to remain in Paris and disguised Uhde's homosexuality. Uhde organised Delaunay-Terk's first solo exhibition, where she displayed her vividly coloured figurative paintings, and he introduced her to artists and writers in Paris who were beginning to make names for themselves. One of these was Robert Delaunay, and in 1910, she and Uhde divorced so that she and Delaunay could marry. In 1911, she made for their newborn son a quilt of coloured patches of fabric that resembled textiles she had seen in Ukraine as a young child. She recalled: 'When it was finished, the arrangement of the pieces of material seemed to me to evoke Cubist conceptions and we then tried to apply the same process to other objects and paintings.'

She and Delaunay also studied Michel Eugène Chevreul's colour theories, and they began to produce paintings based on simultaneous colour

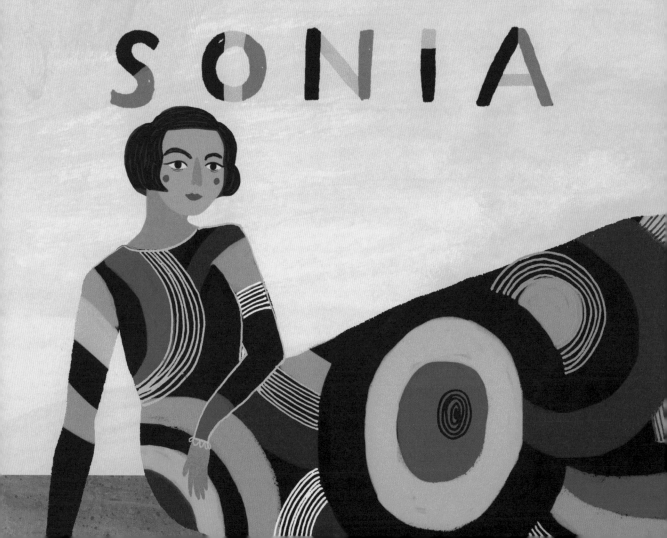

contrasts blended with Cubist ideas. With her textile work, Delaunay-Terk helped to eradicate distinctions between fine art and crafts, and she collaborated with several poets including Blaise Cendrars, Arthur Rimbaud, Tristan Tzara, Apollinaire and Stéphane Mallarmé, declaring: 'Painting is a form of poetry, colours are words, their relations rhythms.'

After the First World War, Delaunay-Terk opened an interiors and fashion boutique called Casa Sonia. Five years later, she designed the set and costumes for Tzara's play *Le Cœur à Gaz*, and in 1926, she illustrated the cover of *Vogue*. She also designed costumes and furniture for films, while her textiles label, Tissus Delaunay, sold around the world. Her use of coloured squares especially inspired Paul Klee (1879–1940) in works such as *Flora on Sand* (1927).

Was influenced by the colour work of

VINCENT VAN GOGH

DELAUNAY -TERK

Inspired many artists, including

Was close friends with Bauhaus colleague

JOAN MIRO

WASSILY KANDINSKY

A TALENTED violinist and painter, Paul Klee was the son of a music teacher, and music was a powerful influence on his art, as were Cubism, Expressionism and Surrealism. He regularly played his violin before beginning a painting, and his art often referenced music.

Klee moved to Munich from Switzerland to study art when he was nineteen years old, and then went to Italy to study the great Italian masters. By 1905, he had developed innovative techniques, such as drawing with a needle on a blackened pane of glass, and his first exhibited work was a series of etchings he called *Inventions*. In Munich in 1911, he met Wassily Kandinsky (1866–1944), Franz Marc (1880–1916) and August Macke (1887–1914) and joined their Expressionist group, der Blaue Reiter (the Blue Rider). He also studied the work of others who were experimenting with new ideas, such as Sonia and Robert Delaunay with Orphism, and Pablo Picasso and Georges Braque with Cubism. However, he was apprehensive about using colour, preferring to draw and make prints rather than paint. Then, in 1914, he visited Tunisia. The vivid light and natural vibrancy there completely changed his attitude, and he famously wrote: 'Colour and I are one. I am a painter.' Klee suddenly became a great colourist. During the First World War, he painted camouflage on aircraft, and after the war taught at the avant-garde art and design school, the Bauhaus, in Weimar and then Dessau, in the bookbinding, stained glass and mural painting workshops, and also in elemental design theory.

A transcendentalist, Klee followed the philosophy that emerged from English and German Romanticism, Immanuel Kant and German Idealism, ultimately believing that people are at their best and succeed when they are truly independent and that the visual world is just one of several realities. Defying categorisation, Klee's diverse body of work, with its simplified, naïve and witty style — often blending both figurative and abstract elements — expresses that philosophy. Aiming to ignore all recent modern art movements, to create his own style devoid of preconceptions and to avoid being artistically categorised, he wrote: 'I want to be as though newborn, knowing nothing, absolutely nothing about Europe . . . to be almost primitive.' It was from this stance that he taught Annelise Else Frieda Fleischmann (1899–1994) at the Bauhaus from 1922. She later recounted how she considered Klee to be a superlative genius, especially because of his ability to combine abstract and geometric with natural and organic.

ANNI ALBERS (born Annelise Fleischmann) was raised in Berlin by middle-class parents, but rather than getting married and staying home as expected, aged twenty-three she joined the radical Bauhaus art and design school. She went on to combine the ancient craft of hand-weaving with distinctly modern art ideas.

At first, Anni studied painting with the German Impressionist Martin Brandenburg (1870–1919), but soon travelled to Weimar and joined the Bauhaus, which, although it aspired to equality between the sexes, still discouraged women from learning certain disciplines, including painting. So, following most other female students there, she joined the weaving workshop, where she was inspired by her tutors Gunta Stölzl (1897–1983) and Paul Klee. Klee showed her that the process of creating a work of art was as important as the work itself, that colour and pattern could align

with music, and that certain symbols, colours and marks could connect with viewers' subconscious minds. Independently, she read and researched the history of textiles, visited museums and was particularly inspired by the book *Textiles of Ancient Peru and their Techniques* (1924) by Raoul d'Harcourt. She began to incorporate Peruvian colours and patterns into her innovative weaving methods and techniques.

Bauhaus students were expected to produce designs that could be manufactured industrially, and Anni created handmade prototypes that could be mechanically produced. In 1922, she met Josef Albers (1888–1926), a student in the glass workshop, and they married in 1925. From then onwards, they collaborated. In 1929, Anni created a wall covering for a new auditorium designed by Hannes Meyer (1889–1954). With its interlaced synthetic fibres, cotton and cellophane, it reflected light and

absorbed sound, thus pioneering ideas for theatre design and acoustics. From 1931 to 1932, Anni was in charge of the Bauhaus weaving workshop, but in 1933, with the rise of Nazism, the Bauhaus closed, and she and Josef emigrated to the United States. They both taught in North Carolina, and Anni made frequent visits to Mexico, Chile and Peru, collecting artefacts and researching the ancient cultures to inform her colourful designs. She also made jewellery. In the 1950s, with her husband, she moved to New Haven, Connecticut, where she drew on sources from Africa, Asia and the Americas and continued to investigate new weaving methods and designs. In her later years, she took up printmaking.

More than a century after Anni grew up in Berlin, the Ethiopian-born American artist Julie Mehretu (b.1970) worked in the same city, and was made a visual arts fellow at the American Academy there.

TRACEY EMIN

LOIS MAILOU JONES

ANNI ALBERS

USING LAYERS of acrylic paint overlaid with pen, pencil and ink marks, Julie Mehretu builds up large-scale images by incorporating elements of architecture, such as columns and façades, with other things such as maps, charts, flags and building plans, conveying the pace, energy and emotion of sprawling modern urban environments. Some of her works allude to actual places; others are completely abstract. Often, she includes historical, geographical, social and political elements. Far from being haphazard or spontaneous, these free-looking works are carefully planned and formed to portray layers of time, drawing on a huge range of influences, such as Cubism and Constructivism; individuals, such as Bernard Tschumi (b.1944) and Tadao Ando (b.1941); Chinese and Japanese calligraphy, Baroque art and landscape painting; and comics and graffiti. Overall, Mehretu's

work conveys aspects of the frenzied world that continually evolves around us.

Mehretu was born in Ethiopia. At six years old, she moved with her family to the United States. She took a degree in Michigan, followed by a year in Senegal at Cheikh Anta Diop University, and then did a master's degree in fine art at Rhode Island School of Design. In 1999, she moved to New York City and began to create her vibrant works, mixing media and creating intricate and detailed images, often on unusual surfaces such as vellum and polyester sheeting known as Mylar. She explains: 'What I want to investigate . . . is how we are all influenced by this mega-city, this crossroads, how we're all dependent on the grid, and yet the tiniest transaction can define us and differentiate the individual from the whole.'

Although recognised for her paintings, Mehretu also experiments with printmaking

JACKSON POLLOCK

and has worked collaboratively on projects in Minneapolis, San Francisco, Los Angeles and New York City. She has won many prestigious awards and commissions. While in Berlin in 2007, she was commissioned by the Deutsche Guggenheim. *Grey Area* (2008–09) is the resulting suite of paintings, which represent Berlin as a scene of destruction and evolution, through façades of nineteenth-century buildings that were damaged or destroyed in the Second World War. She says: 'I work with source material that I am interested in conceptually, politically, or even just visually. I . . . project it, trace it, break it up, re-contextualise it, layer one on the other.' Her rhythmic, flowing works, which blend abstraction and references from the real world, are frequently compared to the abstract, colourful paintings and brushmarks of Wassily Kandinsky.

JULIE MEHRETU

Was inspired by the approaches to light and colour taken by

PURSUING HIS belief that art can be a manifestation of spirituality, Wassily Kandinsky created abstract paintings, lithographs and wood engravings. Transcending cultural, physical and national boundaries, he also taught and wrote about his theories, explaining that abstract images can express spirituality far more than those observed directly from nature.

Kandinsky evolved from creating figurative paintings to producing distortions of reality through colour and shape, before finally focusing solely on colourful planes, lines and shapes. After graduating from art school, he studied law and economics at the University of Moscow. For a while, he was a successful lawyer, but he soon moved to Munich to study art with Anton Ažbe (1862–1905) and Franz von Stuck (1863–1928). From 1906 to 1908, he travelled around Europe and, inspired by Fauvism and Expressionism, began painting with vivid colours and distorted representational elements. He was also influenced by the folk art and fairy tales of the Vologda region, where he was born, and the colourful, light-filled paintings of Claude Monet.

Eventually, Kandinsky settled in Bavaria, where he became involved with the philosophical and spiritual movements theosophy and anthroposophy, which had a powerful effect on his art. In 1911, he helped to found the Expressionist group der Blaue Reiter (the Blue Rider), which encouraged a more spiritual approach to art. That same year, he attended a concert that included Arnold Schoenberg and afterwards wrote to Schoenberg. The two men became friends, influencing each other's ideas; from then on, Kandinsky began painting colours and forms that, for him, corresponded to music. In 1912, his book *Concerning the Spiritual in Art* defined three types of painting that he called impressions, improvisations and compositions – words also used for musical arrangements. For Kandinsky, rhythmic shapes, colours and patterns all had underlying universal meanings. After the Nazis expelled him from Germany at the start of the First World War, he initially stayed in Russia, then returned to Germany, where he taught design, painting and theory at the Bauhaus until it closed in 1933.

Kandinsky had synaesthesia, a condition that meant he 'saw' or 'heard' colours when he heard sounds or music, and he believed that colour had its own vibrating, spiritual dimensions. In his essay of 1926, 'Point and Line to Plane', he investigated these ideas further, which led to some of the earliest abstract paintings produced in Western art. However, the first abstract paintings pre-dated Kandinsky's by approximately five years and were produced by the German artist Hilma af Klint (1862–1944).

Drew inspiration from Goethe's theory of colours, like

SIMILAR TO Wassily Kandinsky, Hilma af Klint was strongly influenced by the spiritual movements theosophy, founded by the Russian philosopher Madame Blavatsky, and anthroposophy, developed by the Austrian philosopher Rudolf Steiner. Steiner in particular believed that spirituality could be rationally understood through both science and art. Like Kandinsky and Piet Mondrian, Klint sought to convey elements of spirituality through her art, without referring to any particular religion. Her paintings became based on her explorations of colour, science and mathematics, her religious beliefs and her studies of organic objects, including shells and flowers.

Klint was born in Sweden and her early childhood was spent at a naval academy where her father was based, with summers spent in Adelsö, an island in Lake Mälaren, where her fascination with nature began. She moved to Stockholm when she was ten, but little else is known of her childhood. At the age of eighteen she studied portrait painting, but when her ten-year-old sister Hermina died, she turned to religion, spiritualism and the occult, and began to attend séances. Two years later, she enrolled at the Royal Academy of Arts in Stockholm, among the first generation of female students to be accepted there. After graduating with honours, she earned a living painting traditional-style landscapes and portraits, and in 1896, with four female artist friends, she began a group called The Five (De Fem). Every week until 1906, they held séances, experimenting with free-flowing, unconsciously produced writing and drawing, preceding Surrealist automatism by decades. A vegetarian when it was relatively uncommon, Klint was also a botanist, and she researched natural sciences, mathematics and religions, being especially fascinated by recent scientific discoveries and inventions. Contrastingly, while producing her intuitive imagery, she was also painting and drawing plants and animals in close detail.

When she was forty-two, Klint experienced a message during a séance. She claimed she heard a voice urging her to create paintings in order to 'proclaim a new philosophy of life'. For almost ten years, she produced a series of 193 paintings, *Paintings for the Temple*. In 1908, she invited Steiner to see her work, but he disapproved of her declaration that she was a medium and advised her not to show her paintings for fifty years. By the time her paintings were exhibited, many had decided that Kandinsky's paintings were the first abstract works. Fifty years later, Agnes Martin (1912–2004) explored and expressed similarly spiritual, although Buddhist, beliefs, through her own contemplative and unique paintings.

DESPITE OFTEN being categorised as a Minimalist, Agnes Martin described herself as an Abstract Expressionist. Her pared-down abstract paintings were an amalgamation of influences — nature, Zen Buddhism and Taoism — and through them, she aimed to inspire moods or emotions in viewers. She once wrote: 'My paintings are not about what is seen; they are about what is forever in the mind.'

Martin was born on a remote farm in Saskatchewan. At the age of nineteen, during the Great Depression, she moved to the United States and studied art while also training as a teacher. She became fascinated by Zen Buddhism and Taoism, living increasingly by the philosophies of both. She moved frequently, teaching wherever she went, and each time building her own organic dwellings. Diagnosed with schizophrenia in her forties, Martin lived alone for most of her adult life. For several years, she lived in Taos, New Mexico, where she made abstract paintings featuring organic forms, inspired by the landscape around her. Persuaded by artist, art dealer and collector Betty Parsons (1900–82), who especially promoted Abstract Expressionist art, she moved to New York in 1957, where she lived with a community of artists, who enjoyed cheap rents, large loft spaces and views of the East River. There, Martin established herself in the male-dominated art world, through her large-scale, evocative works featuring precisely drawn pencilled grids with pale and subtle colour washes and gesso coatings. She described these paintings as a mix of Zen Buddhist, Taoist and Transcendentalist ideas: 'A world without objects, without interruption . . . or obstacle. It is to accept the necessity of . . . going into a field of vision as you would cross an empty beach to look at the ocean.'

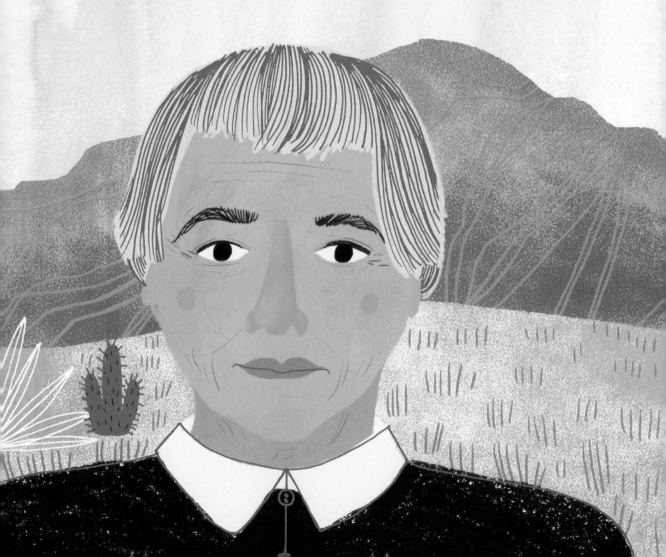

In 1967, at the age of fifty-five, Martin lost her home through a new urban development. Her friend, Ad Reinhardt (1913–67), died suddenly, and her schizophrenia worsened. She returned to Taos, where she stopped painting, instead writing and meditating for seven years. In 1974, she began painting once again, but this time, she no longer focused on her meticulously pencilled grids, instead producing bold geometric works with subtle colour arrangements inspired by the arid desert landscape that surrounded her.

While she was still living in New York, Martin produced a painting titled *Summer* (1964), inspired by her meditations and beliefs in Buddhist and Taoist philosophies. Sixty years previously, the Scottish artist Margaret Macdonald (1864–1933) had produced a large and tranquil painting that she had also titled *Summer*.

Had a strong impact on the ideas of

EVA HESSE

While in Taos, New Mexico, she became friends with

GEORGIA O'KEEFFE

AGNES MARTIN

IN SCOTLAND in the late nineteenth century, Art Nouveau was referred to as the Glasgow Style, in recognition of the group of designers known as the Glasgow Four: Charles Rennie Mackintosh (1868–1928), James Herbert MacNair (1868–1955) and sisters Margaret and Frances Macdonald (1873–1921). Creative, prolific and determined, Margaret Macdonald became a successful artist and designer in a predominantly male domain.

Unusually for the time, both Margaret and Frances attended a progressive school that gave female pupils a broad education. They were also among the first female students to attend the Glasgow School of Art; while there, they and three other female students were known as 'the Glasgow Girls'. Margaret was skilled in a variety of media, including watercolour, metalwork, embroidery and textiles, and her elongated, ethereal style often featured intense, rich colours. It also displayed her admiration of Japanese design, the art of Gustav Klimt (1862–1918), Celtic imagery, literature and folklore.

While she and Frances were at Glasgow School of Art, Francis Newbery (1855–1946), the head of the school, introduced them to Mackintosh and his friend, fellow architecture student MacNair. They formed the Glasgow Four, collaborating on art and design projects that expressed their fascination with mysticism and symbolism. Eventually, Margaret married Mackintosh, and Frances married MacNair. As a couple, Macdonald and Mackintosh produced avant-garde designs for interiors that were sought after throughout Europe and the United States, and influenced the development of Art Nouveau.

Examples of these interiors include their first marital home, the House for an Art Lover (1901), the Rose Boudoir (1902) and the Willow

Tearooms in Glasgow (1903). Macdonald produced decorative gesso panels and, between 1895 and 1924, contributed to more than forty exhibitions throughout Europe and the United States, where she was recognised and celebrated. Mackintosh believed that she was a genius and in 1927, he said to her: 'You must remember that in all my architectural efforts you have been half, if not three-quarters, of them.'

Macdonald spent her career trying to eradicate divisions between fine art, decorative design and crafts. As a fine artist, she produced paintings and designs for interiors. A quarter of a century later, Sophie Taeuber-Arp, a fine artist, painter, sculptor, textile designer, furniture and interior designer, architect and dancer, steadfastly challenged the traditional divisions between the fine and applied arts even more avidly.

Had a profound influence on

GUSTAV KLIMT

MARGARET MACDONALD

Was good friends with

DURING THE First World War, several artists, writers and musicians performed in the Cabaret Voltaire in Zurich, initiating the Dada movement. Sophie Taeuber-Arp was one of them. Throughout her career, she was determined to eradicate traditionally perceived differences between applied, fine and performance arts, as well as man-made, rigid notions about gender, class and nationality. She also became one of the most important practitioners of Constructivism outside Russia.

Taeuber-Arp studied drawing, textile design and weaving in Switzerland, as well as bead work and dance in Munich and Hamburg. In 1915, back in Switzerland, she began creating Cubist-inspired abstract paintings and sculptures. Also in 1915, she met Hans Arp and they collaborated on Dada creations. Taeuber-Arp participated in performances – dancing and staging puppet shows, and designing puppets, costumes and sets – while also teaching weaving and other textile arts at the Zurich School of Arts and Crafts. In addition, she joined the Swiss Werkbund, a professional group of artist-designers. She began producing textile and graphic works that are among the earliest Constructivist artworks, as she tried to balance and contrast colours with geometric forms. In her dance and puppetry, Taeuber-Arp similarly explored contrasts of free and restricted movements using costumes and masks. She and Hans Arp married in 1922; as well as collaborating with each other, they also collaborated with others, for example, with Theo van Doesburg on the interior designs for the refurbishment of the Café de L'Aubette in Strasbourg.

During the 1920s, Taeuber-Arp lived mainly in Paris and she became a French citizen in 1926. Over the next few years, she joined a number of art groups that promoted abstract art, including Cercle et Carré in 1929 and Abstraction-Création in 1931. She also joined a Swiss group, Allianz, which began in 1937, the same year that she founded and edited *Plastique* magazine, 'devoted to the study and appreciation of abstract art'. In 1940, to avoid the Nazi occupation of Paris, the Arps fled to Grasse in Vichy France, and two years later, they returned to Switzerland. Until her untimely death from accidental carbon monoxide poisoning at the age of fifty-four, Taeuber-Arp kept in contact with her circle of close friends, which included the artists Sonia Delaunay-Terk, Robert Delaunay, Wassily Kandinsky, Joan Miró (1893–1983) and Marcel Duchamp.

MARCEL

DUCHAMP

Was lifelong friends with

 CONSTANTIN BRANCUSI

CHALLENGING THE notion of what constitutes art, Marcel Duchamp was one of the most influential artists of the twentieth century, often described as 'the father of Conceptual art' because of his insistence that art should be driven by ideas rather than by technical skills.

One of seven children, Duchamp was born in Normandy, France, and he and two of his elder brothers, Jacques Villon and Raymond Duchamp-Villon, became artists. In 1904, Duchamp followed his brothers to Paris where he studied painting at the Académie Julian. His first paintings were inspired by Post-Impressionism. At the age of eighteen, he completed national military service, and then learned various processes working for a printer in Rouen. Blending repetitive imagery with elements of Cubism, he began to explore ways of conveying motion in static paintings, becoming fascinated with the idea of depicting the fourth dimension. He also hated art that focused purely on aesthetics. In 1912, he painted *Nude Descending a Staircase, No. 2*, which was an attempt to show motion in a static painting. Creating an uproar before it was even exhibited, the painting was rejected by the hanging committee of the Salon des Indépendants, including his brothers, with the explanation: 'A nude never descends stairs – a nude reclines.' The painting continued to evoke scandal when exhibited at New York's Armory

Show in 1913. Also in 1913, he exhibited his first readymade: a bicycle wheel on a stool, pioneering the idea of minimising the importance of artistic skill. Using the term 'readymade' to describe any mass-produced object taken out of its usual context and promoted as art, Duchamp explained that prefabricated objects freed him from the 'trap' of conforming to a particular style. At first derided, readymades later became an essential part of several art movements, including Conceptual art and Minimalism.

One of Duchamp's large three-dimensional works, *The Bride Stripped Bare by Her Bachelors, Even* (1915–23), often called *The Large Glass*, took eleven years from conception to completion (three years of preparatory studies, followed by eight years of execution). Combining chance procedures with careful planning, it introduced new materials and concepts into art. In 1915, Duchamp emigrated to New York, where he produced several more readymades, including a urinal titled *Fountain* (1917), which changed the path of art, raising questions of originality and authenticity. In 1920, in order to explore ideas of sexual identity, he adopted an alternate female persona, 'Rrose Sélavy', and soon after became good friends with the American artist Alexander Calder (1898–1976), who had moved to Paris in 1926. Duchamp described Calder's kinetic sculptures as 'mobiles', and the name stuck.

 99

THE INVENTOR of free-moving, or kinetic, sculptures, Alexander Calder studied mechanical engineering and applied kinetics before attending the Art Students League of New York for two years. In 1925, he worked as a freelance artist for the *National Police Gazette*, and spent a couple of weeks sketching at a circus, which had a significant effect on his career. In 1926, he had an exhibition of paintings in New York, and later that year went to Paris to study art at the Académie de la Grande Chaumière. There, he began creating *Cirque Calder* (1926–31): models of animals and human figures made of wood and wire, which he moved manually to perform, while giving a French commentary. He first exhibited his circus at the Salon des Indépendants in Paris in 1927. From then, he divided his time between France and the United States.

In 1929, he began to make jewellery using wire, and also created more figurative oil paintings.

However, a visit to the studio of Piet Mondrian changed his outlook. Within a year, he exhibited his first abstract wire works and produced his initial, ground-breaking, mechanised sculptures, which pioneered kinetic art. Initially, he used motors to make these sculptures move, but soon abandoned the mechanics and relied on air currents instead. Marcel Duchamp named these moving artworks 'mobiles', while Hans Arp called his static sculptures 'stabiles'. Wire became Calder's main method of 'drawing', and his mobiles were usually made of lightweight wire and painted tin so that they moved even in the faintest air currents.

In 1933, Calder began to create even larger hanging works and outdoor sculptures, concurrently making sets and costumes for theatrical productions; he also continued to stage performances of *Cirque Calder*. During the Second

World War, he created brightly coloured gouache paintings while also producing sculptures, the latter of which were predominantly made of wood because of metal shortages. In 1943, he was the youngest artist to have a retrospective exhibition at the Museum of Modern Art in New York.

Several years before, he had met Joan Miró in Paris and the two became good friends. Calder created *Portrait for Joan Miró* out of wire in *c.*1930, and Miró wrote a poem about Calder. They both produced works titled *Constellations*, and Calder once declared: 'Archaeologists will tell you there's a little bit of Miró in Calder and a little bit of Calder in Miró.' Describing his mobiles as 'four-dimensional drawings', Calder sought to respond to Miró's paintings by generating similar outlines, spaces, shapes and colours, but as mobiles so that they constantly changed.

Was a close friend of

PIET MONDRIAN

ALEXANDER CALDER

Joan miró

Collaborated on designs for Sergei Diaghilev with

EARLY IN his career, Joan Miró was inspired by the folk art and Romanesque church frescoes of his native Catalan region, as well as by seventeenth-century Dutch realism, and he mainly painted still lifes, landscapes and genre scenes. Later, however, his unconventional painting, printing, collage and assemblage techniques had a powerful impact on the development of Surrealism and graphic design.

Miró was born in Barcelona, and following his parents' wishes he studied commerce and then worked for two years as an office clerk. After suffering a mental and physical breakdown, however, his parents took him to convalesce in Montroig, near Tarragona, and in 1912 he went to study art in Barcelona. He began his artistic career experimenting with bold colours and fractional, angular shapes, inspired by Fauvism and Cubism. In 1920, he moved to Paris where he started to paint in a more graphic, symbolic style. In 1924, he joined the Surrealist group. Extremely poor, Miró recalled that he often went to bed hungry, and the dream-like images he made – apparently from hunger-induced hallucinations – seemed to be a response to what the founder of Surrealism, André Breton, described as 'pure psychic automatism'.

Miró's art became increasingly enigmatic, representing interpretations of his dreams, imagination and unconscious. He began to explore collage and sculptural assemblage, as well as etchings, and also created sets and costumes for ballets. In 1934, his art was exhibited in both France and the United States, and during the Spanish Civil War, political tension and war became prominent themes. Because of the turmoil in Spain, Miró moved to Paris in October 1936, and three years later, at the outbreak of the Second World War, he moved with his family to Normandy. In 1941, however, in fear of the advancing Nazi forces, he and his family escaped to Majorca. He continued to create experimental biomorphic forms, geometric shapes and semi-abstracted objects in large paintings, sculpture, ceramics and engravings, balancing his automatism with meticulous planning and careful rendering, explaining: 'I begin painting and as I paint, the picture begins to assert itself . . . The first stage is free, unconscious [but] the second stage is carefully calculated.' His unconscious approach inspired the later Abstract Expressionists.

In 1938, Miró met Louise Bourgeois (1911–2010) when she rented an apartment in a building where Breton had a gallery. Miró met her on several further occasions, including in New York after she had moved there, and again in 1947, when he worked with her and other artists at the famous printing studio, Atelier 17.

OVER HER long career, Louise Bourgeois produced three-dimensional art that was often sexually explicit or that expressed her childhood experiences and emotions, especially her father's infidelity to her mother. Growing up in Paris, she lived in an apartment above a gallery where her parents repaired and sold tapestries, and they spent weekends at their villa and workshop in the country restoring antique tapestries. From a young age, Bourgeois created designs for the worn or missing sections of these tapestries and also washed and mended them, alongside her mother, with whom she was extremely close. Tensions arose however, as her tutor, who lived with the family, was also her father's mistress.

Bourgeois initially studied mathematics at the Sorbonne but also began to work with a variety of artistic media. After the death of her mother when Bourgeois was twenty-one, she left her mathematics course and studied art at the École du Louvre, the Académie Ranson, the Académie Julian, the Académie de la Grande Chaumière and the École des Beaux-Arts. For a while, she also worked as an assistant to Fernand Léger, and she moved into an apartment in the same building as André Breton's gallery, where she became familiar with the work of the Surrealists. She began to exhibit her work at the Salon d'Automne and opened her own gallery in a sectioned-off area of her father's tapestry showroom, showing her prints and paintings. She also worked briefly as an art dealer, meeting and becoming friends with Joan Miró, among others.

During this period, she met the American critic and art historian Robert Goldwater (1907–73), whom she married, and in 1938, she moved with him to New York. There, she began producing sculpture, often stylised figures

created with unusual materials. Bourgeois socialised in the prominent artists' circles of the time, taught art, was politically active as a socialist and feminist, and explored her original ideas in painting, printmaking, sculpture, performance and installations, using a wide range of materials and motifs. During the 1970s, both her father and her husband died, and she began to produce more overtly feminist works. She also hosted Sunday salons where she critiqued the work of students and young artists.

In 1982, Bourgeois became the first female artist to have a retrospective at the Museum of Modern Art in New York, and in 2006, she met the British artist Tracey Emin (b.1963). After expressing an interest in doing a series of joint works, they exhibited sixteen collaborative canvases in an exhibition titled 'Do Not Abandon Me' in New York and London.

MARCEL DUCHAMP

she described as a 'father figure'

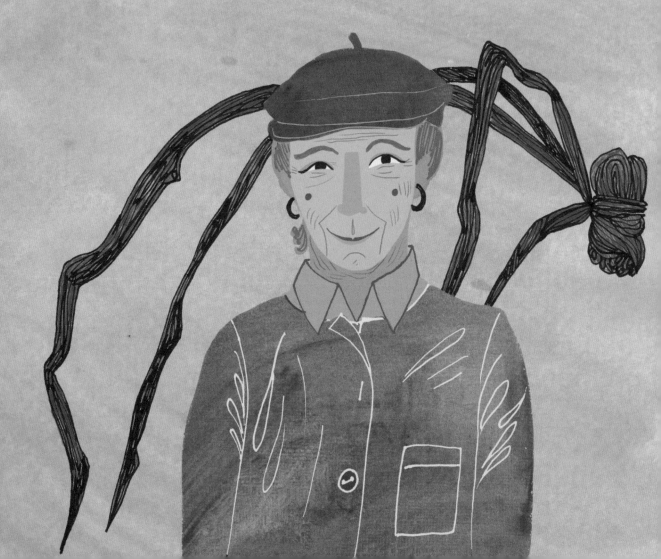

BEST KNOWN for her autobiographical artwork, which explores traumatic events, family tragedies, promiscuity, rape and abortion, Tracey Emin works with a range of materials and processes, including readymades, neon lighting and traditional 'domestic' crafts. Her attention-grabbing work often contrasts with traditionally established expectations of femininity.

Emin grew up in a hotel on the Kent coast with her mother and twin brother. She studied fashion, then fine art, and in 1989, she completed a master's degree in painting at London's Royal College of Art. In London, in 1988, Emin joined with a group of young artists and participated in an exhibition called 'Freeze'. Their art was new and daring, and they were nicknamed collectively 'Young British Artists' or YBAs. In 1993, she and another YBA, Sarah Lucas (b.1962), set up

The Shop in East London to market their work. That year, Emin also held her first solo exhibition in London, titled 'My Major Retrospective', in which she created a part-installation, part-autobiographical archive of personal items and photographs. In 1997, she exhibited in another controversial art show, 'Sensation', at London's Royal Academy of Arts.

Emin was propelled to fame in 1999, when her installation *My Bed* (1998) was nominated for the prestigious Turner Prize. The bed itself is a readymade, and the detritus and other objects on and around it illustrate a period of depression in her life when she didn't get up for several days after a relationship had ended. *My Bed* is a self-portrait. As part of the work, drawings, needlework and appliqués surround the bed. Craft work like this was traditionally ignored as a merely feminine

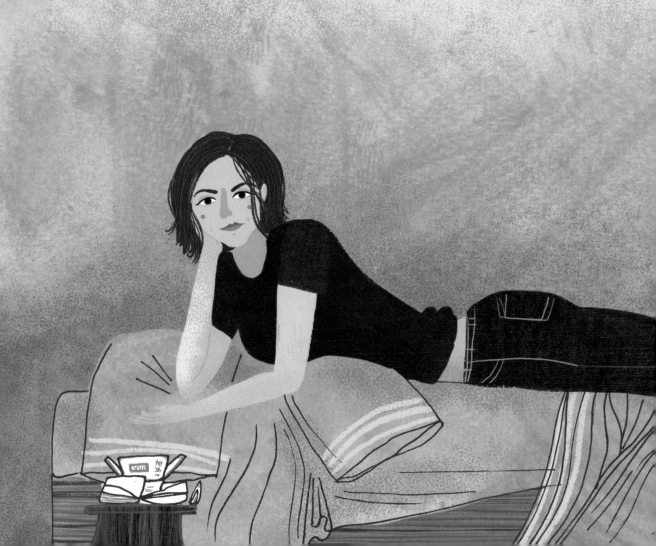

EDVARD MUNCH

pursuit and beneath the consideration of the male-dominated art world. Some of Emin's works include swear words or descriptions of socially taboo or 'unfeminine' subjects.

Despite her controversial art and outspokenness, Emin became a Royal Academician in 2007, marking her acceptance by the official art establishment. She was later also made a professor of drawing at the Royal Academy. In 2013, she was awarded a CBE for her services to the arts. Five years previously, she had made a chess set, once again employing traditional domestic crafts such as appliquéd blankets, needlework and drawings, using the game of chess itself to express the difficulties of romantic relationships. Sixty-four years earlier, in 1944, the German artist Max Ernst (1891–1976) had created a chess set out of wood for an exhibition in New York.

Tracey Emin

PAUL GAUGUIN

profoundly influenced his approach to art

PAUL KLEE

In 1919, he went to Munich to visit

USING FREE association to create art from his subconscious while in a trance-like state, Max Ernst was one of the first artists to use automatism, and his original ideas and techniques aided the development of Dada and Surrealism.

From 1910 to 1914, Ernst studied philosophy, art history, literature, psychology and psychiatry at the University of Bonn and became fascinated by the ideas of Sigmund Freud and Friedrich Nietzsche, as well as by art made by the mentally ill. At the start of the First World War, he was conscripted and served at the forefront of the fighting. Traumatised by his experiences, after the war he began to paint, influenced by the paintings of Vincent van Gogh and August Macke, and by Expressionism and Cubism. In 1919, Ernst became involved in the Cologne Dada group and later exhibited with the Parisian Dada group. As well as painting, he began to create collages using magazines, catalogues and manuals.

In 1922, Ernst moved to Paris and mixed with the Surrealists. His painting *Men Shall Know Nothing of This* (1923) is generally recognised as the first Surrealist painting; he was one of the first to create art based on the theories of Freud's book *The Interpretation of Dreams* (1900). He explored unusual artistic techniques to activate his unconscious, including frottage (from the French verb *frotter*, 'to rub'), in which he rubbed drawing materials over rough surfaces to create impressions of texture; grattage (from the French for 'scraping'), in which he placed a canvas coated with a layer of oil paint over a textured object and then scraped off the paint to create unexpected surfaces; and decalcomania, where he transferred paint from one surface to another. He also began depicting himself as a bird-like creature called Loplop.

When the Second World War broke out, Ernst was arrested for being a 'hostile alien': a German living in France. He was soon released, but then the Nazis invaded France, labelled his work 'degenerate' and arrested him. With the assistance of the American heiress and art collector Peggy Guggenheim (1898–1979), he escaped to the United States, where she became his third wife. In the United States, Ernst worked with Piet Mondrian and Marcel Duchamp, inspiring younger artists, such as Jackson Pollock (1912–56), and the Abstract Expressionists.

Before the war, in 1934 in Paris, Ernst had started to produce sculpture and had befriended the young Swiss artist Alberto Giacometti (1901–66). The two men spent time in each other's studios, discussing sculpture and Surrealism. In 1938, Peggy Guggenheim bought several works by both artists, which she displayed in her London gallery.

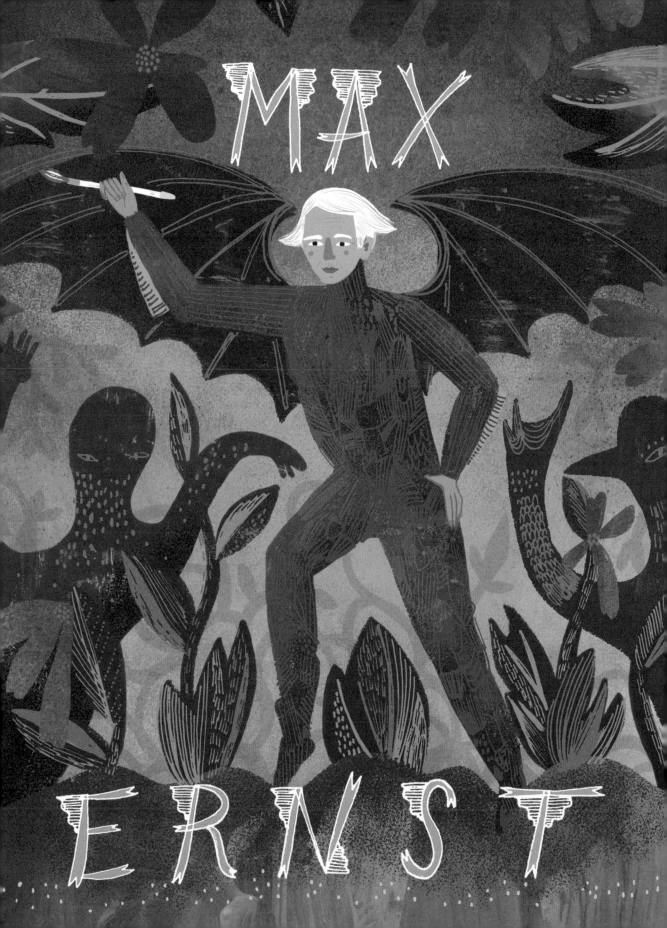

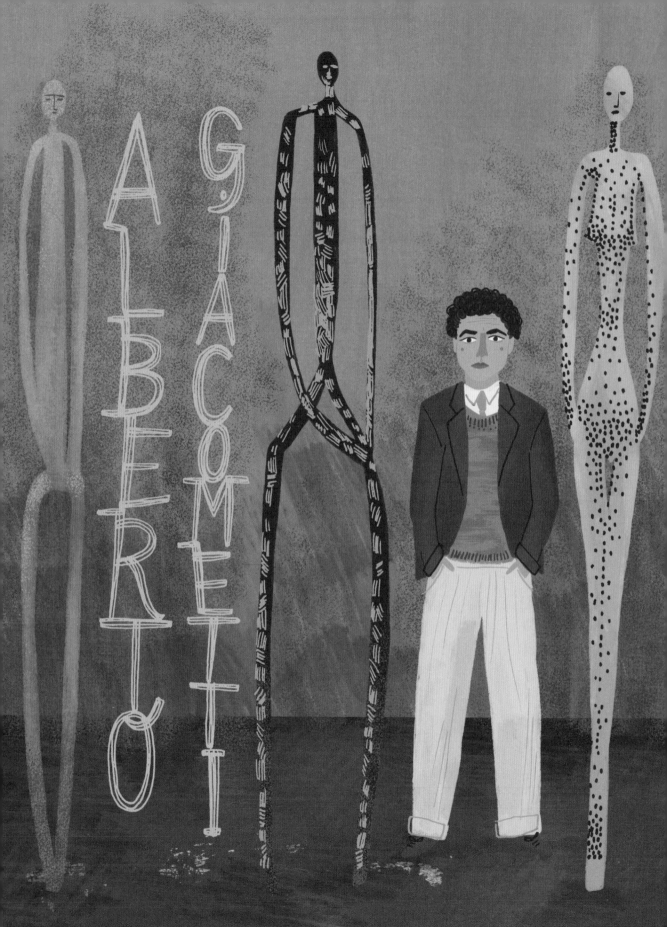

ALBERTO GIACOMETTI

FAMED MAINLY for his spindly figurative sculptures, Alberto Giacometti worked as a Surrealist in the 1930s and as an Existentialist after the Second World War. His art shows astute powers of perception and conveys a sense of alienation and anxiety.

The eldest of four children, Giacometti was born in eastern Switzerland. From a family of artists, Giacometti and his brother Diego (1902–85) became artists and their brother Bruno became an architect. Giacometti studied in Geneva and was fascinated by the apparent simplicity of much African and Egyptian art. At the Venice Biennale, he discovered the work of both Paul Cézanne and Alexander Archipenko. Elsewhere in Italy, he became intrigued by the art of Giotto (1276–1337) and Tintoretto (1519–94). In 1927, he and Diego shared a studio in Paris, where he began exhibiting. That year, he also exhibited with his father in Zurich. After meeting the Surrealist André Masson (1896–1987), Giacometti created fantastic images derived from his unconscious, and in 1935, he began producing sketchy drawings and sculpted figures with textured surfaces, long limbs and small heads. All sculptors consider the negative spaces around and between their work, but in Giacometti's figures it is particularly significant. His figures personify the themes of disconnection, of being alone in a crowd and universal feelings of detachment and vulnerability.

In Paris at the beginning of the Second World War, Giacometti forged friendships with Picasso and the writers Jean-Paul Sartre and Simone de Beauvoir, who each had an influence on his work. However, he spent most of the war in Geneva, where he began to produce spindly, textured sculptures. After the war, Giacometti led the way as an Existentialist artist, summarising the philosophy through his art as he established the theme of individuals suffering alone. Although he worked with life models, including his brother and wife, he did not aim to replicate appearances. Instead, by disregarding volume and distorting his figures, Giacometti created the essence of a person, or dog, or whatever animal he was representing. His slender figures appear as if seen from a distance, expressing human emotions through gestures and stance, projecting ideas about self-consciousness and how we relate to others.

Between the two world wars, Giacometti studied Cézanne's drawings and paintings especially where he had explored structure. He made a number of studies from Cézanne's work, and he later reflected that he had spent the war years meditating on Cézanne's aims and achievements.

SCORNED AND ridiculed during his lifetime for his innovative approach to painting, Paul Cézanne was one of the most original and influential artists of the nineteenth century, and hugely important in the development of Cubism.

Born in Aix-en-Provence, he was persuaded by his father to study law, but while at law school, he also enrolled at the local art school. At the age of twenty-one, he left his studies to join his friend Émile Zola in Paris. There, he copied paintings in the Louvre and the Musée du Luxembourg. At that time, the future Impressionists were developing new ideas and he mixed with them. In 1872, Cézanne moved to Auvers-sur-Oise, where he painted with Camille Pissarro, who encouraged him to paint outdoors. Although Cézanne exhibited with the Impressionists in Paris in 1874 and 1877, he soon abandoned Impressionism. However, he continued to paint outdoors and returned in 1878 to Provence where he changed his approach. Whereas most of the Impressionists sought to capture the effects of light, Cézanne was more interested in exploring the structures of things, and so his brushstrokes became more angled and descriptive. In the 1880s, he painted numerous still lifes, aiming to convey the essence of the objects through forms, colours and negative spaces, abandoning the traditions of perspective and paint application that had been accepted for centuries. He painted some subjects repeatedly, to try to reveal 'something other than reality' and also to make 'something solid and enduring like the art of the museums'.

Cézanne's investigation into underlying structure was a completely new way of representing the world. After his death, Picasso called him 'my one and only master . . . the father of us all', Paul Klee described him as 'the supreme master', and

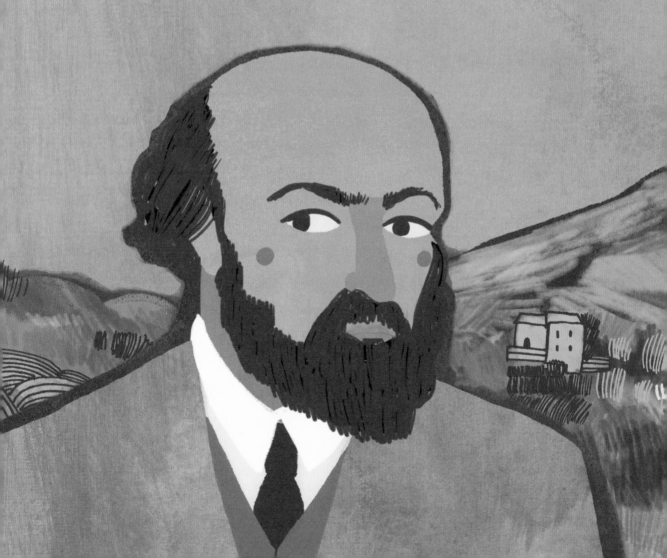

Henri Matisse (1869–1954) said he was 'a kind of benevolent god of painting'. Picasso and Georges Braque developed Cubism in recognition of Cézanne's method of painting objects from several viewpoints at once.

Cézanne took painstaking care with every painting, but often despaired when he finished because he did not believe the work was good enough. He was the first artist to completely break with traditions of Western painting that dated back to the fifteenth century, despite the hostility of many. Yet after his death, he became the subject of several retrospectives. In 1937, Lois Mailou Jones (1905–98) spent a year in Paris, admiring his work in retrospectives and other exhibitions, and most of her early still lifes were made from her studies of Cézanne while at the Académie Julian in Paris.

Had a profound impact on

PABLO PICASSO

PAUL CÉZANNE

FROM A young age, Lois Mailou Jones decided that she wanted to be an artist, and through her art and her teaching, she particularly helped to further an African American influence in the arts.

Mailou Jones won scholarships to take classes at the Museum of Fine Arts, Boston, where she also studied for her master's degree. At the age of seventeen, she had her first solo exhibition, but she started her career selling her textile designs to department stores and manufacturers. In 1928, she formed the art department at the Palmer Memorial Institute in North Carolina, and in 1930, she began teaching design and watercolour painting at Howard University in Washington, DC. She stayed there for nearly fifty years, mentoring thousands of students.

One of the first African American artists to paint subjects other than portraiture, Mailou Jones was influenced by the Harlem Renaissance that occurred between the two world wars, when many African Americans explored and expanded upon their own creativity. Similarly, Mailou Jones's designs, paintings and illustrations incorporate elements of African traditions. In Paris in 1937, she studied painting at the Académie Julian and began to produce landscapes, street scenes, portraits and figure studies in an Impressionist and Post-Impressionist style, using vibrant colours and lively brushstrokes. She also painted outdoors and exhibited in Parisian exhibitions. For the first time, in France, she felt free from racial prejudice and spent many summers there.

On her return to America, she began to express her African heritage and her experiences of being black in the United States. After marrying a Haitian artist in 1953, she also incorporated Haitian subjects in her work. Mailou Jones became an energetic supporter of international artists, and in 1970 she spent four months visiting eleven African countries. Back in the United States, she

became a prominent advocate of race relations as she tried to build greater understanding between American and African cultures; she was invited to the White House eight times, to foreign embassies, college campuses and international events. She also painted the portraits of many heads of state.

Mailou Jones painted expressive images that conveyed her mixed racial heritage and her Parisian training. Similarly, Amrita Sher-Gil (1913–41) spent her career exploring and expressing the various cultures of her background through her Parisian art training. Sher-Gil went to India for the first time in 1921 when she was nine years old; Mailou Jones went to Africa for the first time at the age of sixty-five. Both artists convey layers of influence, identity, heritage and nationality through their bold painting styles.

MARCEL DUCHAMP

HENRI MATISSE

Studied at the Académie Julian in Paris, whose alumni include

LOÏS MAILOU JONES

Studied at the Académie de la Grande Chaumière, whose past students include

TAMARA DE LEMPICKA

An associate of the Société Nationale des Beaux-Arts, to which the first woman admitted was

SUZANNE VALADON

WITH HER mixed heritage, Amrita Sher-Gil fused European painting methods with Indian subjects and colours, and became one of India's most celebrated modern artists.

Born in Budapest, Sher-Gil had a Sikh father and a Hungarian-Jewish mother. When she was nine, the family moved from Hungary to Shimla in the foothills of the Himalayas where she learned to play piano and violin, and was taught art by private tutors. Sher-Gil moved to Florence and for a short time attended the Santa Annunziata art school. Seeing paintings by great Italian masters influenced her greatly. She returned to India a few months later, and from 1929 to 1934 she lived in Paris, first entering the Académie de la Grande Chaumière and then the École des Beaux-Arts. At the Académie de la Grande Chaumière, her teacher Lucien Simon (1861–1945) particularly inspired her, as did the colours and expressiveness of the paintings of Paul Cézanne and Paul Gauguin (1848–1903). At that time, she mainly painted self-portraits, portraits, still lifes and landscapes in a lifelike but stylised manner. In 1933, her painting *Young Girls* (1932) was awarded a gold medal at the Société Nationale des Beaux-Arts. It features her sister Indira and a semi-clothed friend, and has been interpreted as representing different sides of Sher-Gil's personality: the dutiful young woman and the bohemian, sexually active artist. She was elected an associate of the society, the youngest art student and the only Asian artist ever to receive that accolade.

In her art and her personal life, Sher-Gil explored her European and Indian identities, and alternated between wearing Indian saris and European fashions. She also indulged in the wilder side of Parisian society, conducting affairs with both men and women. On finishing her training, she returned to India and spent the next few years travelling, observing the people around her and absorbing ideas from Mughal and Pahari miniature painting, and the Ajanta and Ellora cave paintings. She became obsessed with painting the poor, using intense colours that included rich reds, golden ochres, browns, brilliant blues and greens. She wrote to a friend: 'I can only paint in India. Europe belongs to Picasso, Matisse, Braque. India belongs only to me.' Soon after however, aged just twenty-eight, she died suddenly, possibly through poisoning, despite her doctor husband being with her.

In 1933, during a visit to the Tate in London, Sher-Gil was inspired by Gauguin's Tahitian painting *Faa Iheihe* (1898). In 1934, she painted *Self-Portrait as Tahitian* in response.

PAUL GAUGUIN

Neku Hiva

Ua Ho

Faku Hu

Hiva

Ua Pou

Mot

Tuhuala

Fatu Hiva

TAHITI

Lived at 8 rue de la Grande Chaumière, which was occupied twenty-one years later by

AMEDEO MODIGLIANI

IN HIS late thirties, Paul Gauguin abandoned his wife and children in order to pursue his artistic dreams.

Working against popular opinion, Gauguin created art that disregarded all previous approaches. After mastering Impressionist methods, he changed his style and was later classed as a Post-Impressionist. Determined to escape modernity, he stayed in rural Brittany, where he became the leader of the Pont-Aven School. He explored scientific colour theories and created a style that he called Synthetism (others labelled it Cloisonnism), with bold, flat areas of colour separated by black lines that resembled cloisonné enamels. His style is also described as Primitivism, reflecting his admiration of the art of earlier cultures, and his ideas inspired a group of artists known as Les Nabis (meaning 'The Prophets' in Hebrew and Arabic).

As a baby, Gauguin left Paris and lived with his mother, sister and uncle in Lima, Peru, before returning to Paris when he was seven years old. Later, he joined the merchant navy, worked as a stockbroker for eleven years and married a Danish girl with whom he had five children. In 1874, Gauguin saw the first Impressionist exhibition and bought several works. Encouraged by Camille Pissarro, he began to paint as a hobby, and one of his paintings was accepted at the Paris Salon in 1876. Inspired by the work of Paul Cézanne in particular, he exhibited with the Impressionists four times. In 1882, when the stock market crashed, he decided to earn his living as an artist. After two years of struggling, however, Gauguin left his wife and children in Denmark and moved to Brittany, which was cheaper and less industrialised than the rest of France. There, he developed his flat-looking, colourful style, believing that the art of earlier, less sophisticated cultures was more honest than academic art. He worked in Denmark, Panama, Martinique, Brittany and the south of France, but eventually — still poor and disillusioned — moved to Tahiti, seeking a tropical paradise away from artificiality. There, he discovered that even Tahiti was becoming modernised, so in his art, he fused reality with his own ideas; it was largely unappreciated and he spent his final years poor, ill and alone.

In October 1888, Gauguin travelled from Paris to stay in Arles in southern France with Vincent van Gogh, who was renting four rooms in a house that he planned to turn into an artists' commune. During the nine weeks they lived together, they argued frequently, and after a particularly explosive row, Gauguin left. Van Gogh famously cut off part of his earlobe.

WITH HIS tragic biography now as well known as his original and expressive art, Vincent van Gogh has become a household name, but during his lifetime he and his work were scorned.

The son of a Protestant pastor and the eldest of six children, van Gogh grew up in the Netherlands. At the age of sixteen, he began working as an art dealer and travelled between the Hague, London and Paris. After losing his job, he tried teaching in England and working as a preacher in the Borinage mining district of Belgium. When all ended unhappily, his younger brother Theo, an art dealer, encouraged him to become an artist. In 1881, he took lessons with Anton Mauve (1838–88) and was influenced by the work of Frans Hals (c.1580–1666), Rembrandt (1606–69), Jean-François Millet (1814–75) and Peter Paul Rubens (1577–1640). Five years later, he joined Theo in Paris and studied for a short time with Fernand Cormon (1845–1924). Van Gogh met Camille Pissarro, Claude Monet, Henri de Toulouse-Lautrec, Paul Gauguin and Paul Signac (1863–1935); inspired by them, he lightened his palette and shortened his brushstrokes. He also started collecting and copying Japanese *ukiyo-e* prints. Within two years, he moved to Arles in Provence, where the dazzling light inspired him to brighten his palette even further and develop a distinctive, expressive style. Planning to start an artists' colony, he persuaded Gauguin to join him, but they argued violently. After two months his fragile mental health deteriorated and he allegedly lunged at Gauguin with a razor blade, then cut off part of his own earlobe when Gauguin left. After time in an asylum, van Gogh moved to Auvers-sur-Oise on the outskirts of Paris, which was closer to Theo and where he could be treated by Dr Paul Gachet, a modern-thinking physician and amateur artist.

VINCENT VAN GOGH

Despite suffering frequent bouts of depression and other debilitating symptoms, he worked tirelessly in Auvers. His swirling brushmarks, thick paint and vibrant colours were unique — and misunderstood. Depression took over, and in July 1890, he shot himself in the abdomen. Two days later, he died in Theo's arms.

When van Gogh arrived in Paris in 1886, he enrolled at Cormon's open studio where the artists drew from casts of classical sculptures and painted from nude models. Cormon worked in a different studio and came in once a week to give the students instruction. Van Gogh only attended for about three months, but while there he met Toulouse-Lautrec. In 1887, they exhibited together, and because both felt shunned by society, van Gogh and Toulouse-Lautrec became particularly good friends.

PIET MONDRIAN

SONIA DELAUNAY-TERK

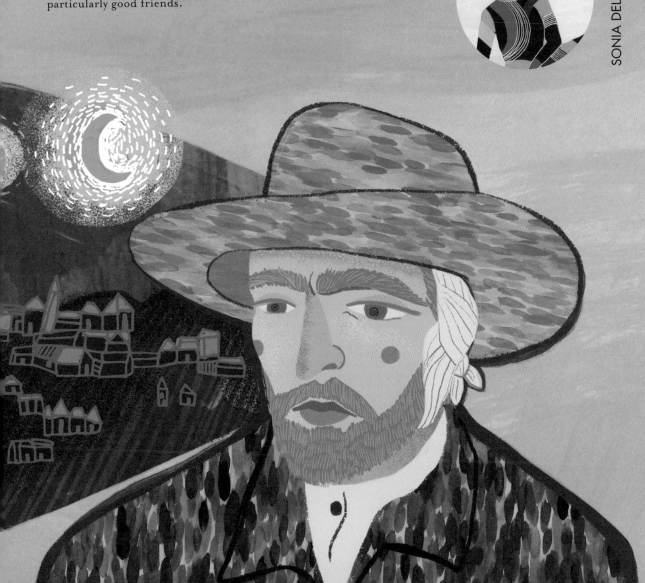

HENRI DE

TOULOUSE-LAUTREC

MOULIN ROUGE

THE LAST in line of a noble aristocratic family, Henri de Toulouse-Lautrec grew up on a family estate near Toulouse. After breaking both his legs as an adolescent, his body grew to adult size but his legs did not (attributed to an inherited illness); his head looked abnormally large and he walked with difficulty. So, instead of continuing the family line, he began to study art in Paris with a leading French painter, Léon Bonnat (1833–1922), and then with Fernand Cormon, before moving to a studio in Montmartre. He also sketched in local cafés, cabarets and nightclubs, where he befriended artists, writers, performers and prostitutes – and drank heavily.

In addition to painting in oils, gouache, tempera and pastels, Toulouse-Lautrec drew and produced prints. Few other artists of the time used printmaking as an art form, but he experimented with colour lithography, and his advertisements, posters, illustrations and theatre programmes were incredibly innovative, influencing not only the Art Nouveau style but also future artists such as Andy Warhol, through his merging of high and low art. His energetic paintings involved distinctive lines and colours. In turn, he was influenced by Edgar Degas and Paul Gauguin, as well as by Japanese

ukiyo-e prints. His fluid lines, asymmetrical compositions and vivid colours captured the atmosphere and people around him, conveying rhythms and dynamism that preceded the early twentieth-century movements of Fauvism and Cubism. Furthermore, his astute powers of observation illustrate his empathy with those on the edge of society. He often used *peinture à l'essence* (oil thinned with turpentine) on cardboard with loose, sketchy brushwork. Lithography allowed him to print large posters in colour, and one of his innovative techniques was '*crachis*', a splatter effect. He became the most important poster artist of Paris and his minimal lines and bold colours captured the characteristics of some of the most well-known figures of Paris at the time.

In the spring of 1887, Toulouse-Lautrec met Suzanne Valadon (1865–1938), when she modelled for him. She lived in a nearby apartment, and Toulouse-Lautrec took an interest in her and her art. He was the first person to buy her work. As well as advising her on her painting, he also began suggesting what she should wear, and he persuaded her to change her name from Marie to Suzanne. By then, Toulouse-Lautrec's studio had become a meeting place for local artists and writers, and Suzanne helped host his soirées.

UNCONVENTIONAL AND often shocking, Suzanne Valadon became an artists' model so that she could study the painters' methods. Born Marie-Clémentine Valadon, she was the illegitimate daughter of a woman who worked in a hotel. In 1870, mother and daughter moved to Montmartre in Paris, and Valadon grew up among pimps, prostitutes and artists. From the age of ten, she took odd jobs, and at fourteen, she became a trapeze artist in a circus but had to leave after a fall. A year later, in 1881, Le Chat Noir cabaret opened. Frequented by artists, poets and writers, it was an immediate success, and Valadon visited regularly. Small and beautiful, she began modelling for painters, including Berthe Morisot (1841–95), Pierre Puvis de Chavannes (1824–98), Théophile Steinlen (1859–1923), Pierre-Auguste Renoir (1841–1919) and Henri de Toulouse-Lautrec. Several also gave her art instruction.

Toulouse-Lautrec persuaded her to change her name to Suzanne, took her sketching and introduced her to Edgar Degas, who became her mentor. He also taught her drawing and etching techniques and organised her exhibitions. At the age of eighteen, she had an illegitimate son, Maurice, and her friend Miguel Utrillo (1862–1934) gave the baby his name. Valadon always denied they were lovers, and never told anyone her child's true paternity.

Few female artists of the time painted nudes, but in addition to producing female portraits, still lifes and landscapes, Valadon painted nudes from a female perspective, with bold, expressive renderings. Despite this audacity, her work sold well, and in 1894, she became the first woman painter to be admitted to the Société Nationale des Beaux-Arts. In 1893, she had a short-lived affair with the composer Erik Satie, who became

SUZANNE VALADON

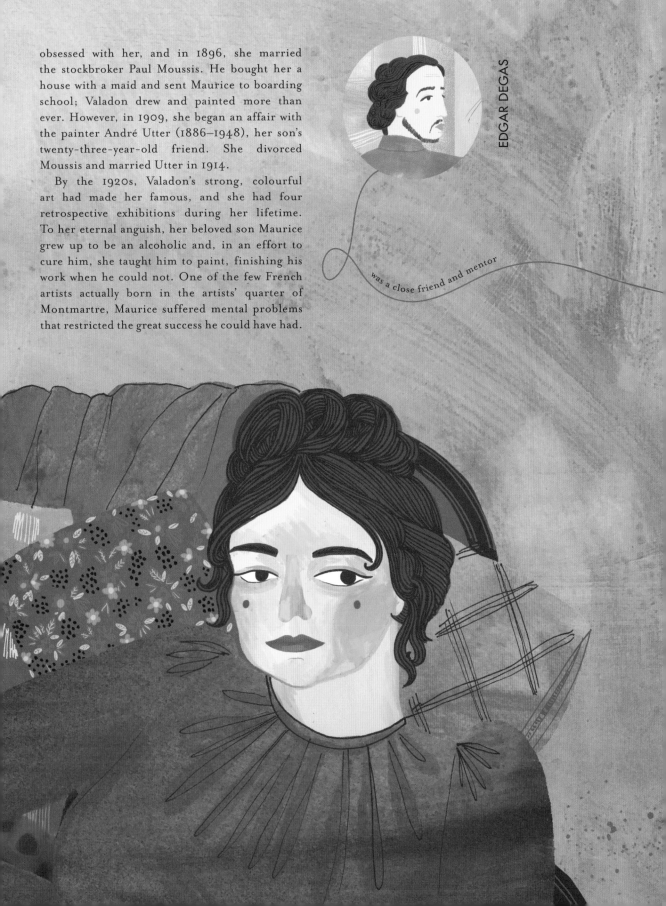

obsessed with her, and in 1896, she married the stockbroker Paul Moussis. He bought her a house with a maid and sent Maurice to boarding school; Valadon drew and painted more than ever. However, in 1909, she began an affair with the painter André Utter (1886–1948), her son's twenty-three-year-old friend. She divorced Moussis and married Utter in 1914.

By the 1920s, Valadon's strong, colourful art had made her famous, and she had four retrospective exhibitions during her lifetime. To her eternal anguish, her beloved son Maurice grew up to be an alcoholic and, in an effort to cure him, she taught him to paint, finishing his work when he could not. One of the few French artists actually born in the artists' quarter of Montmartre, Maurice suffered mental problems that restricted the great success he could have had.

EDGAR DEGAS

was a close friend and mentor

THE ILLEGITIMATE son of eighteen-year-old Suzanne Valadon, Maurice Utrillo painted in and around his birthplace: the Montmartre quarter of Paris. Valadon never revealed the identity of her son's father and speculation persists, but in 1891, her friend Miguel Utrillo signed a legal document acknowledging paternity. It is, however, unlikely that Miguel Utrillo was Maurice's father.

Utrillo grew up with his mother and grandmother, and from an early age he became increasingly dependent on alcohol. When he was twenty-one, Valadon taught him to paint in an attempt to give him some direction. In a bold and broadly geometric style, he began drawing and painting colourful street scenes of Montmartre, including its old windmills, churches, shops and cafés, often from postcards rather than *en plein air*. He shared Valadon's studio at 12 rue Cortot and sold his first work in 1905.

In 1909, he exhibited at the Salon d'Automne and received positive reviews, but his successes were interspersed with treatments for alcoholism and periods in mental asylums. Following an attack of delirium tremens in 1912, he spent two months in a clinic in the Paris suburbs, and afterwards went to Brittany and Corsica to paint. The next few years saw him interned intermittently in various asylums, yet in between, his work attracted critical attention and by 1920 he was internationally acclaimed. For a while, he painted landscapes around the village of Montmagny, north of Paris, still with thickly impastoed paint, but then returned to Montmartre, where he continued to convey a sense of flattened space. Despite his success, Utrillo remained unstable, and in order to keep him away from the bars of Montmartre, Valadon moved to a château near Lyon. Although he returned to Montmartre,

MAURICE UTRILLO

he spent many summers at the château. In 1925, he created sets and costumes for the ballet *Barabau*, performed in Paris by the Ballets Russes. In 1928, in recognition of his art, the French government awarded Utrillo the Cross of the Légion d'Honneur, and in 1935 he married one of Valadon's friends. Six years his senior, his wife inspired his religious fervour, but Valadon accused her of being after her son's money.

The period from 1909 to 1912 became known as Utrillo's 'white period', in which he used large amounts of zinc white impasto paint applied with a palette knife, sometimes mixed with plaster. During that time, he painted a colourful view of Notre Dame in the Île de la Cité in Paris. Seven years earlier, Henri Matisse had also painted the subject.

AMEDEO MODIGLIANI

PLACE DU TEATRE

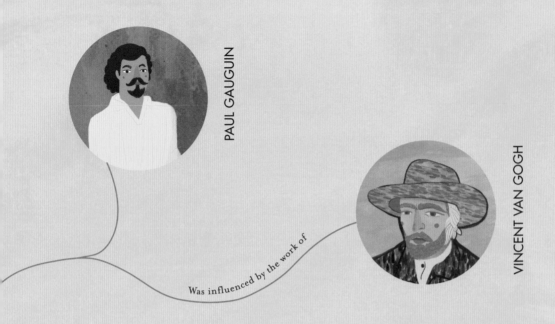

PAUL GAUGUIN

VINCENT VAN GOGH

Was influenced by the work of

THE VIVID colours and rhythmic compositions of Henri Matisse made him one of the most significant artists of the twentieth century. Although he studied law, his mother gave him a box of paints while he was recovering from appendicitis. He later recalled: 'From the moment I held the box of colours in my hands, I knew this was my life.' In 1891, he studied at the Académie Julian and the École des Beaux-Arts in Paris and was inspired by Neoclassicism, Impressionism, Symbolism and Japanese art, and also by Vincent van Gogh, Édouard Manet, Paul Cézanne and Paul Gauguin, which compelled him to experiment with bold colours and loose paint application. Visits to Corsica and the south of France intensified his fascination with light and colour.

In 1903, he and friends organised the Salon d'Automne as an alternative to the conservative Paris Salon, and in 1905, he painted with André Derain, using brilliant colours and dynamic brushmarks. That year, they and their friends exhibited vibrant, distorted paintings at the Salon d'Automne. The art critic Louis Vauxcelles described the paintings as 'wild beasts' (fauves), and the term stuck. Matisse was seen as the leader of Fauvism, and the short-lived movement had an extensive influence on the development of art. While his friend Pablo Picasso deconstructed

forms into Cubist planes, he constructed them through colour. After seeing exhibitions of Asian art and visiting North Africa, he also began to incorporate some decorative aspects of Islamic art and angularities of African sculpture, declaring that he wanted his art to be one 'of balance, of purity and serenity'. From 1911 to 1916, Matisse depicted figures in Eastern-style interiors, and from 1917 to 1930, he moved to the south of France and brightened his colours even further. Confined to a wheelchair following surgery for cancer in 1941, he began his cut-out technique, drawing and painting shapes in gouache on paper, which assistants then cut out and glued onto huge canvases. Using the same technique, he designed stained glass windows for the Chapelle du Rosaire de Vence in southern France.

It is not clear precisely when Matisse met Pierre Bonnard (1867–1947), but in 1906, Bonnard sent Matisse an invitation to his solo exhibition in Paris, which Matisse kept for the rest of his life. The two men were friends for more than forty years, each admiring the work of the other. They owned paintings by each other, wrote many letters and postcards to each other, and shared a preference for bold colours, contrasting patterns and the same subjects: interiors, still lifes, landscapes and the female nude.

HENRI MATISSE

A MEMBER of the group of painters known as Les Nabis, who painted images with flat-looking colour and who aimed for a greater connection between art and everyday life, Pierre Bonnard was especially influenced by Symbolism and Japanese ukiyo-e woodblock prints. His small paintings are often called 'intimist', and although influenced by both Impressionism and Paul Gauguin, he developed his own style of unmodulated colour and flattened spaces. He painted many of his scenes from memory, capturing the spirit of the moment rather than literal depictions.

Bonnard initially studied law at the Sorbonne and briefly practised as a barrister. He then studied art at the École des Beaux-Arts and the Académie Julian, where he met Maurice Denis, Paul Sérusier (1864–1927), Ker-Xavier Roussel (1867–1944), Paul Ranson (1864–1909), Félix Vallotton (1865–1925) and Édouard Vuillard (1868–1940), who collectively became the Nabis.

In 1891, he met Henri de Toulouse-Lautrec and began showing his work at the annual exhibition of the Société des Artistes Indépendants. He also illustrated magazines and books, theatre programmes, exhibition announcements and sheet music, making use of the latest technical innovations in colour lithography, and designed a stained glass window for Louis Comfort Tiffany (1848–1943).

In addition to his intimist works, Bonnard produced large-scale paintings, exploring elements of the eighteenth-century French 'grand manner' style. After visiting the south of France, from 1910 he began capturing the dazzling light of the area, exploring more intense colours and creating complex compositions of friends and family members in sunlit interiors and gardens. In the 1920s, he produced a series of paintings on the theme of a nude in a bath, usually from an overhead viewpoint, mixing contrasts of colour

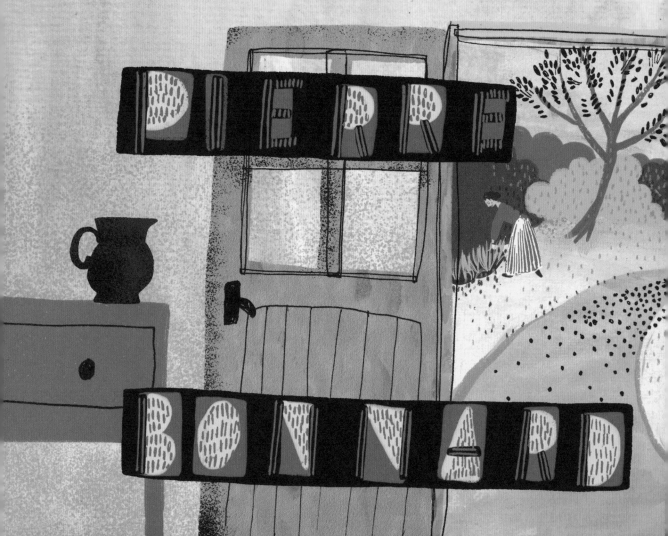

and pattern. After that, his subjects continued to include still lifes, self-portraits, street scenes, seascapes of Saint-Tropez and views of his garden at Le Cannet, near Cannes, where he lived from 1925 after marrying his model and companion of thirty years, Maria Boursin (1869–1942). She became one of his main subjects; he painted her almost 400 times.

In the spring of 1890, Bonnard visited an exhibition at the École des Beaux-Arts organised by Siegfried Bing, who imported and sold Japanese artefacts. Bing also published a monthly journal, *Le Japon Artistique*. Bonnard was greatly influenced by Japanese design, as was another artist working at a similar time in Vienna. Although Gustav Klimt and Bonnard never met, their styles show similarities through this Japanese influence, as seen in Bonnard's painting *The Dressing Gown* (1892).

LOUISE BOURGEOIS

LOÏS MAILOU JONES

GUSTAV
KLIMT

Was greatly inspired by

OFTEN REGARDED as the greatest painter of the Art Nouveau period, Gustav Klimt joined the Viennese School of Applied Arts when he was fourteen years old. Three years later, he, his brother Ernst (1864–92) and their friend Franz Matsch (1861–1942) secured several prestigious painting commissions. In 1883, they opened their own studio in Vienna, calling themselves the Künstlercompagnie (Company of Artists). They profited from what became known as the 'Ringstrasse' era, a period that lasted from 1857 to 1914 when a grand boulevard – the Ringstrasse (ring road) – was built in Vienna and the wealthy moved in, generating numerous opportunities for artists. At the time, Klimt adhered to academic artistic expectations, painting with meticulous detail.

Tragically, at the end of 1892, Klimt's father and brother died; Klimt was left financially responsible for his mother, sisters, Ernst's widow and their baby. He began a close friendship with Ernst's widow's sister, Emilie Flöge, which lasted for the rest of his life. After the deaths of his father and brother, Klimt moved away from his academic painting style, adding symbolism and glimmering patterned surfaces. In 1897, he and several other artists resigned from the official Vienna Artists' Association and began the Vienna Secession. Although they did not favour any one particular style, they rejected academic art and instead supported young avant-garde

artists. They exhibited their own work regularly and invited international artists to exhibit with them. Klimt was the first president of the Vienna Secession and also worked on its periodical, *Ver Sacrum* (meaning 'sacred spring').

Klimt's personal, sinuous style both echoed and influenced the prevailing Art Nouveau style. In 1900, *Philosophy*, one of three murals he was painting for the University of Vienna, was shown at the seventh Vienna Secession exhibition. With its nudes and somewhat unsettling symbolic imagery, the work caused a scandal. When the other two murals, *Medicine* and *Jurisprudence*, were displayed in subsequent exhibitions, a petition was created to prevent them from being installed. However, when *Medicine* was exhibited in Paris, it was awarded the Grand Prix. During the early 1900s, Klimt worked in what is known as his 'golden phase', producing paintings that feature gold leaf, reminiscent of Byzantine mosaics, such as *The Kiss* (1908). He created several of his most famous works during this period.

Klimt was the primary influence on the artistic development of Egon Schiele (1890–1918) and became the artist's close friend and mentor. They collaborated on the founding of the Kunsthalle (Hall of Art) in 1917, in an attempt to prevent local artists from leaving Austria. Schiele inherited Klimt's focus on erotic images of the female form, but in some ways directly opposed his mentor's Art Nouveau–inspired style.

GREATLY INFLUENCED by Gustav Klimt's themes of women, life and death, Egon Schiele developed a linear and distorted style, in drawings and paintings of overt sexuality that disregarded artistic conventions. Schiele was extraordinarily prolific and an outstanding draughtsman, who produced some of the finest examples of drawing in the twentieth century, yet his life was marked by notoriety and a tragically early death at the age of twenty-eight, three days after the death of his pregnant wife.

Born near Vienna, Schiele entered the School of Arts and Crafts when he was sixteen, before transferring to the Academy of Fine Arts, where he was the youngest student to enrol. Dissatisfied with the academy's conservative teachings, however, he left after three years. Schiele and several other classmates started a collective called Neuekunstgruppe (New Art Group), and in 1907, he contacted Klimt, who advised him and

introduced him to patrons, models and the work of other artists, including Vincent van Gogh, Edvard Munch (1863–1944) and Jan Toorop (1858–1928), as well as to the Wiener Werkstätte, a fine arts society founded by Vienna Secessionists Josef Hoffmann (1870–1956) and Koloman Moser (1868–1918). Schiele participated in several exhibitions with the Vienna Secession and der Blaue Reiter (the Blue Rider). As well as naked women, he occasionally drew and painted nude children and was subsequently accused of seducing a young girl. After spending twenty-four days in jail, he was released with nothing more than 'charges against morality'. He was, however, traumatised by the experience and stopped painting children.

From 1914, Schiele began to smooth his previously jagged lines, creating curves with simple strokes. Frequently painting self-portraits or portraits of those close to him, he worked from

EGON SCHIELE

unusual, often uncomfortable viewpoints, such as from above. In 1915, he married Edith Harms; four days later, he was conscripted. Hardly seeing any real combat throughout the war, he produced several paintings and drawings, and by 1917 he was back in Vienna. That same year, he and Klimt co-founded the city's Kunsthalle, an exhibition space designed to encourage Austrian artists to remain in Austria. The following year, the Vienna Secession held its forty-ninth annual exhibition, which featured Schiele's work prominently. In October, Edith, who was six months pregnant, died of the Spanish flu pandemic that was sweeping across Europe. Three days later, Schiele died too.

In 1910, Schiele painted an expressive painting, *Self-Portrait Screaming*, and in 1912, he painted *Self-Portrait with Raised Bare Shoulder*. Both works were directly inspired by Munch's *The Scream* (1893), which Schiele had seen at the Vienna Kunstschau in 1909.

Painted tortured self-portraits, much like

VINCENT VAN GOGH

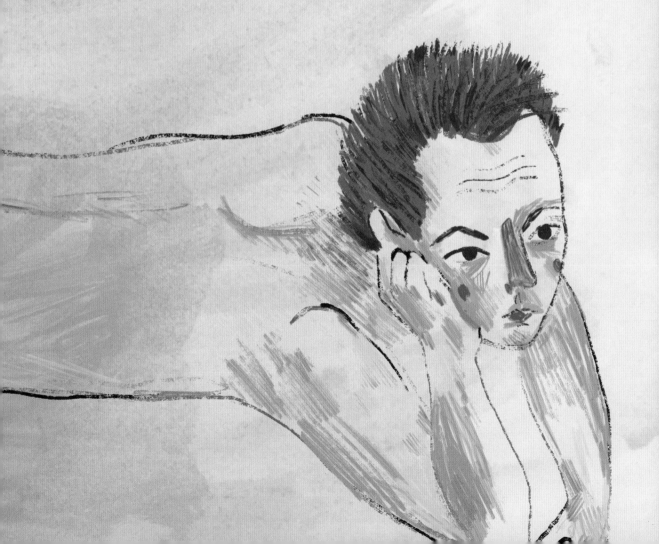

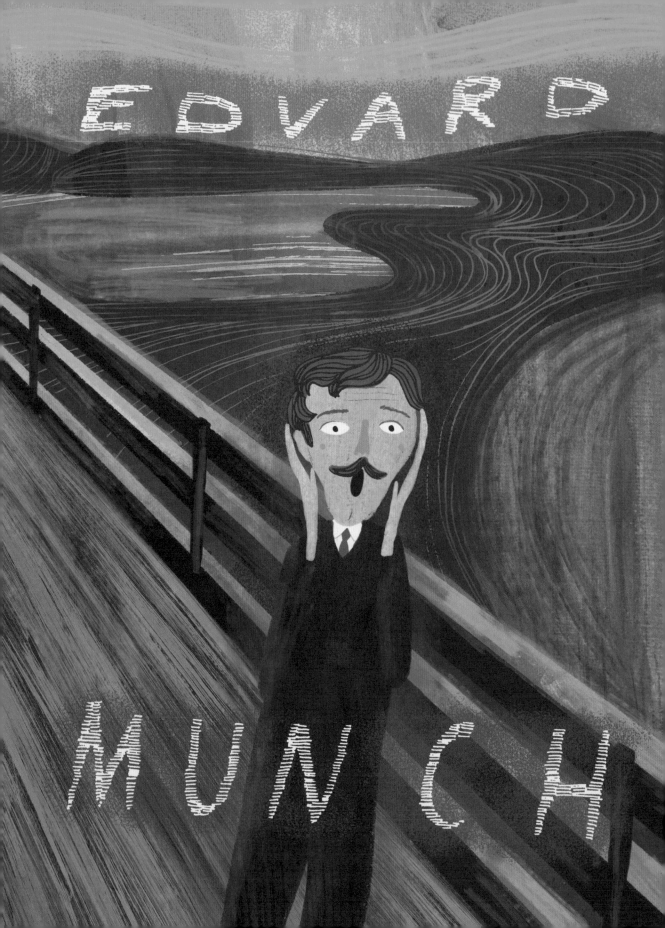

PREOCCUPIED WITH mortality, the Norwegian artist Edvard Munch used intense colour, distorted forms and enigmatic themes, building on Symbolist ideas and his imagination, which had a huge influence on German Expressionism in the early twentieth century.

When he was five years old, Munch lost his mother to tuberculosis, and nine years later, his sister Sophie also died of the disease. His father, a fundamentalist Christian, experienced fits of depression, anger and visions, and he controlled his children oppressively. Munch grew up anxious and morbidly fascinated with death. He was also frequently ill and missed weeks of school. As he convalesced, he drew and painted. At the age of sixteen, he entered technical college, but soon moved to the Royal Drawing School. He also took private art lessons and received a scholarship to study in Paris with Léon Bonnat. He arrived in Paris during the Exposition Universelle of 1889 and discovered the work of Vincent van Gogh, Paul Gauguin and Henri de Toulouse-Lautrec, among others. Throughout the 1880s and 1890s, Munch experimented with brushstrokes, colour and emotional themes, producing etchings, lithographs, woodcuts and paintings. From his time in France, he loosened his style and became generally more expressive. His flowing lines

express both contemporary Art Nouveau fashions and intense psychological revelations.

It is not clear whether or not he had the condition known as synaesthesia — the union of senses, for example the sense of tasting or hearing colours — but his colour combinations often suggest sound. He also associated colours with specific feelings: for example, yellow was sorrow, red was fear, blue was melancholy and violet represented decay. He used unusual materials and expressive, loose lines and brushstrokes. In the autumn of 1908, the effects of excessive alcohol increased Munch's anxiety, and experiencing hallucinations, he was treated in a clinic. After that, his work became brighter and, for the first time, popular. He was made a Knight of the Royal Order of Saint Olav 'for services in art', and his portraits, landscapes and scenes of people at work and play, in broad brushstrokes and vibrant colour, made him financially successful.

Between 1940 and 1943, he painted *Self-Portrait Between the Clock and the Bed*. Approximately forty years later, in 1981, Jasper Johns (b.1930) produced *Between the Clock and the Bed* after Munch's painting. Johns had admired Munch's work for decades, and a friend sent Johns a postcard of Munch's painting after spotting similarities between the bedspread and Johns's trademark cross-hatched brushstrokes.

His later work betrays the influence of

PABLO PICASSO

RECOGNISED FOR his artworks representing the American flag, targets, beer cans and Coca-Cola bottles, the painter, printmaker and sculptor Jasper Johns was a major figure in post-war American art. He is often called a Neo-Dadaist, a Conceptualist and a Minimalist, and his techniques incorporated the sense of spontaneity of Abstract Expressionism, even though they were closely planned. His blend of ordinary objects and painterly style dissolved boundaries between fine art and mass culture.

After his parents divorced, Johns grew up in South Carolina with his grandparents, later living intermittently with his mother and an aunt. At the age of seventeen, he studied at the University of South Carolina, then moved to New York City and studied briefly at the Parsons School of Design. After serving in Japan in the Korean War from 1952 to 1953, he returned to New York where he met Robert Rauschenberg (1925–2008), with whom he had an intense relationship. Rauschenberg introduced Johns to the composer John Cage and the choreographer Merce Cunningham, and the four influenced the direction of post-war avant-garde art and American culture. In 1958, Johns's first solo exhibition received extremely positive attention, propelling him into the public eye. He and Rauschenberg also went to the Philadelphia Museum to see the work of Marcel Duchamp,

whose readymades had a profound impact on both artists. The following year, Duchamp visited Johns's studio, and Johns began emulating elements of Duchamp's practice, including using everyday materials and blurring boundaries between art and life. Among other techniques, Johns used the ancient medium of encaustic, which relies on wax rather than oil to bind pigment. It congeals as each stroke is applied, so every mark is thick and obvious, creating an almost sculptural texture. Johns said his ideal subjects were 'things the mind already knows', because familiar objects have so many meanings for us all.

As the Pop art movement grew and his relationship with Rauschenberg cooled, Johns began working with a darker palette and incorporating more sculptural elements into his paintings, ideas that also emerged from Duchamp and Rauschenberg's influences. In 1968, his studio in South Carolina burnt down, and from then onwards, he split his time between New York City, Saint Martin in the Caribbean and Stony Point, New York. In the 1960s and 1970s, he became interested in the large print runs and layering of saturated colours that could be achieved with screen printing. At the same time, but separately from Johns, Andy Warhol was also experimenting with creating screen prints as fine art and using vibrant, flat-looking and often jarring colours.

138

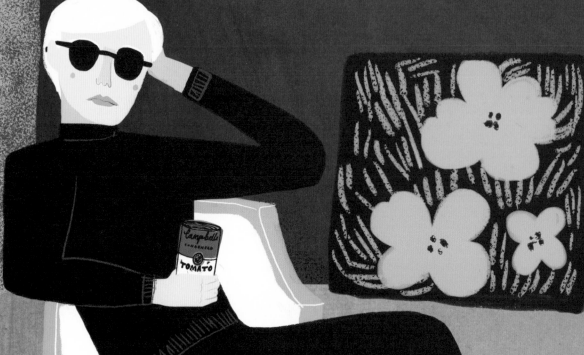

ANDY

Owned over thirty works by

MARCEL DUCHAMP

Revolutionised the art of screen printing, a medium also used by

THE MOST successful and highly paid commercial illustrator in New York, Andy Warhol became famous for his screen-printed images of film stars, packaging and newspaper stories.

Andrew Warhola was born to Czech immigrant parents in Pittsburgh. When he was eight years old, he contracted a neurological illness, Saint Vitus Dance, or Sydenham's chorea. After ten weeks in bed, he was left with nervous tremors and scarring, which made him terribly self-conscious. Over the following two summers, he fell ill again and remained at home, reading comics and drawing. When he was fourteen, his father died unexpectedly, and for the rest of his life, Warhol had an obsessive fear of illness and death.

He studied pictorial design at the Carnegie Institute of Technology, then moved to New York in 1949 and worked as a commercial artist, illustrating for *Glamour*, *Vogue* and *Harper's Bazaar* magazines, as well as creating window displays, advertisements and album covers. Contrasting with the usual precise commercial images, his slightly messy pictures became especially admired.

In 1961, Warhol had a conversation with the art dealer Muriel Latow about moving from commercial into fine art. Latow suggested that he paint images of ordinary soup cans and money; Warhol paid her fifty dollars for the idea. He began painting and then printing Campbell's soup cans, dollar bills, film stars and Coca-Cola

JACKSON POLLOCK

JASPER JOHNS

bottles. From 1962, he created screen prints, which removed the individuality of brushstrokes and could be reproduced hundreds of times. He used bright colours and, as in his commercial art, made each image look slightly messy, so the works defy conventional distinctions between fine and commercial art.

From 1964, Warhol rented a studio that he called the Factory. There, he employed assistants to produce his silkscreen pictures in the fashion of an assembly line, and also expanded into performance art, film-making, photography and sculpture. His unique processes and images from the media propelled him to prominence. Like Marcel Duchamp before him, he promoted the concept that an artist's idea is more important than learnt technical skills, and he helped to change beliefs about art, materials and techniques, as well as about boundaries between high and low art — and he became a celebrity. One of Warhol's fans, Jean-Michel Basquiat (1960–88), was hugely influenced by him, and after they met in 1982, they became great friends and collaborators. Basquiat convinced Warhol to return to painting. Tragically, however, within six years of their meeting, both artists were dead: Warhol following a routine gall bladder operation and Basquiat from drugs.

WITH NO formal art training, before his death at the age of twenty-seven, Jean-Michel Basquiat was known for his raw, gestural style of painting and made the art of graffiti accepted within the mainstream art world.

Basquiat was born in Brooklyn, into a middle-class, multi-ethnic, multilingual household. His father was Haitian-American and his mother was of Puerto Rican heritage. His artistic interests were nurtured by both parents, but especially by his mother who encouraged him to draw and took him to museums and galleries in New York. At the age of seven, he was hit by a car and had to have his spleen removed. While he was recuperating, his mother gave him a copy of *Gray's Anatomy* (first published in 1858). His resulting sinewy figure drawings evolved from *Gray's Anatomy* and graphic novels, and eventually informed his adult paintings. After his parents' divorce, Basquiat lived with his sisters and their father in Puerto Rico, but at the age of seventeen, he dropped out of school and left home. Living with friends, or on the streets, he began a graffiti campaign with others, including his friend Al Diaz (b.1959). He and Diaz invented a character, SAMO (Same Old Shit). Together, Basquiat and Diaz spray-painted images with poems and phrases around New York City, using SAMO as a tag. When they stopped collaborating in 1979, Basquiat wrote 'SAMO is dead' on walls around the city.

In addition to graffiti, Basquiat made collages, T-shirts and postcards. His graffiti on the streets was noticed by the media, and his professional art career ascended. His paintings mixed elements of graffiti with the intuitive approach of Abstract Expressionism. He also expressed his own feelings and anxieties while alluding to African American figures, such as jazz musicians, sports personalities and writers, and he mixed motifs from African, Caribbean, Aztec and Hispanic

cultures with references from high art and popular culture, such as cartoons, often using a unique X-ray type style. He worked with coloured pens, chalk and oil pastels, acrylic paints, watercolours and charcoal, and applied paint with both ends of his brushes. A huge admirer of Andy Warhol, he often similarly incorporated consumer brands and sensational news stories in some of his images, although his art was more satirical than Warhol's.

In the 1980s, in addition to collaborating with Warhol, Basquiat exhibited with other artists, including Julian Schnabel (b.1951) and David Salle (b.1952). In 1980, approximately one hundred artists exhibited at the Times Square Show in New York, which was billed as 'the first radical art show of the '80s'. Among the artists were Basquiat and Jenny Holzer (b.1950).

MAX ERNST

PAULA REGO

JEAN-MICHEL BASQUIAT

AN AMERICAN Neo-Conceptualist, Jenny Holzer is one of many artists to use art as a platform for political protest, but one of the first to use illuminated electronic displays in this way. Focusing on delivering words and ideas in public spaces, since the early 1980s, she has produced large-scale installations, including advertising billboards and projections on buildings and other architectural structures. Since the mid-1990s, text-based light projections have been central to her work, with LED signs becoming her best-known medium. Holzer's text-based art has appeared on such things as T-shirts, billboards and parking meters, and her texts are usually ambiguous, thought-provoking messages, such as 'PRIVATE PROPERTY CREATED CRIME' and 'ABUSE OF POWER COMES AS NO SURPRISE'. Her exploitation of advertising draws on Pop art, while the use of lighting and text is inspired by the ideas of the Minimalists Dan Flavin (1933–96) and Donald Judd.

Born in Ohio, Holzer was interested in art from a young age, and in 1970, she transferred from Duke University in North Carolina to the University of Chicago, where she took a BFA in drawing, printmaking and painting, transferring again to Ohio Christian University in Georgia in 1972, intending to become an abstract painter. In 1975, she took an MFA at the Rhode Island School of Design in New England, and the following year, she moved to New York City and participated in the Whitney Museum's Independent Study Program. This course insists on its students reading extensively and includes set books in literature and philosophy, which especially inspired Holzer. Her first public art project, *Truisms* (1977–79), featured sentences taken from the Independent Study Program's reading list in black italics on white paper, which she wheat-pasted anonymously in public places around Manhattan. In 1981, in her *Living* series, she printed on aluminium and bronze plaques, addressing the necessities of daily life, including eating, breathing, sleeping and relationships, compelling viewers to consider how meaningless messages become when we are bombarded with so many every day.

In 1990, Holzer became the first woman to represent the United States at the Venice Biennale. A few years later, she focused on words taken from those in war-torn regions. In the early twenty-first century, she began using text from declassified government documents, obtained through the Freedom of Information Act, in LED installations and projections. In her own personal art collection, Holzer owns various works by other artists, including two Alice Neel drawings, which she has said are her favourites: 'They are of the dead Che Guevara. She did them darkly, beautifully and sincerely.'

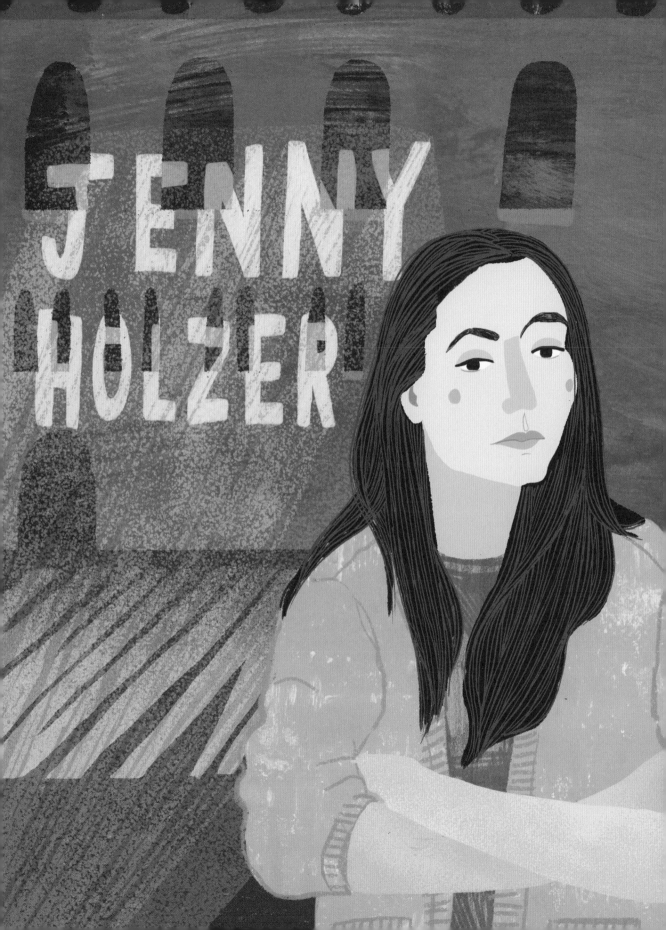

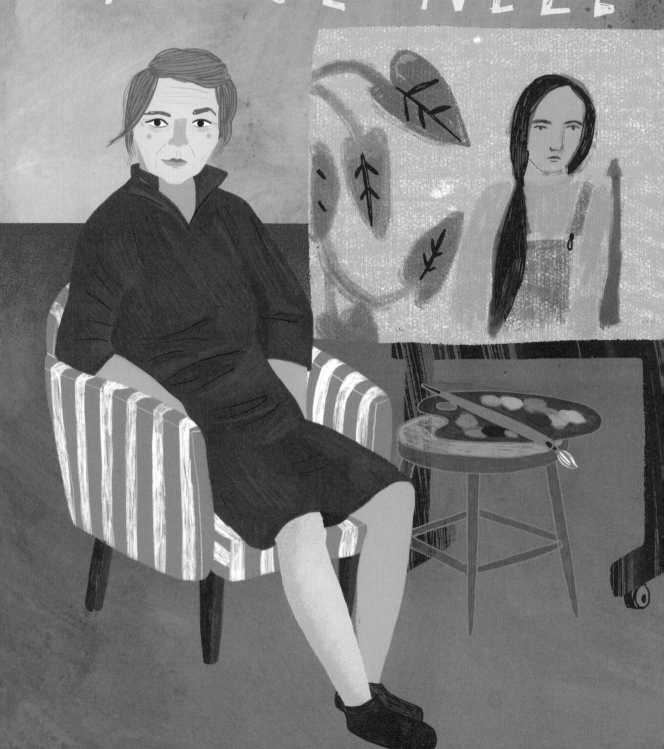

ALICE NEEL

PIERRE BONNARD

FERNAND LEGER

EXPRESSING THE human condition through line and colour, Alice Neel became known for her portraits and figures. This only occurred in the last two decades of her life, though, when she had sixty solo shows.

The fourth of five children from Pennsylvania, Neel initially took a high-paying clerical job to help support her parents. While working, she attended evening art classes and then enrolled on the fine art course at the Philadelphia School of Design for Women, at the age of twenty-one. She was fascinated by the Ashcan School and in particular by the paintings of Robert Henri (1865–1929), who was one of her teachers. In the year that she graduated, she married an upper-class Cuban painter, Carlos Enríquez (1900-57), whom she had met the year before. They moved to Havana, where they lived in a mansion and Neel became involved with the Cuban Vanguardia movement. In 1926, she gave birth to a daughter, Santillana, and early the next year she exhibited at the prominent XII Salón de Bellas Artes in Mexico. Soon after, the family moved to New York, but tragically Santillana died of diphtheria just before her first birthday. From then onwards, Neel explored themes of motherhood, loss and anxiety. In 1928, she had a second daughter, Isabetta, and in the spring of 1930, Enríquez

said he was going to look for somewhere for them to live in Paris. He took Isabetta and returned to Cuba without Neel. She suffered a nervous breakdown, attempted suicide and was hospitalised. After time at her parents' home, she eventually returned to New York where she painted the people around her.

During the Depression, Neel was one of the first artists to work for the Works Progress Administration and she began earning money from her art once more. She also had an affair with a sailor who was a heroin addict and who, in 1934, burnt hundreds of her paintings and drawings. Yet her reputation began to rise. She moved to Spanish Harlem and started to paint her neighbours, specifically women and children. She often painted women nude, pregnant and in various social situations. Through her expressive lines, bright palette and psychological intensity, her female sitters convey a sense of empowerment. When she worked for the Works Progress Administration, Neel was one of 3,748 artists who benefited from Franklin D. Roosevelt's Federal Arts Project. The programme did not distinguish between male and female artists but helped them all during an exceptionally difficult time. Another artist who was also aided by the project was Lee Krasner (1908–84), who called it 'a lifesaver'.

'IT'S TOO bad that women's liberation didn't occur thirty years earlier,' Lee Krasner once mused as she reflected on the male-dominated art world and her perceived role as supportive wife to Jackson Pollock.

Growing up, 'Lee' Krasner changed her name several times. As Lena Krassner she was born in Brooklyn, the sixth of seven children to Russian Jewish parents. By the age of thirteen, she had decided to become a professional artist, which was an unusual choice for an immigrant and a woman. At the time, the only New York City public high school that allowed women to study art was Washington Irving High School, so she enrolled there. In July 1928, her sister Rose died, and according to tradition, the next sister in age should have married her brother-in-law and raised her sister's daughters, but Lee refused. Instead, that September, she joined the National Academy of Design, where her teachers tried to suppress her 'unfeminine' independent approach and give her a classical art training, including drawing anatomically correct figures and learning Old Master techniques. For a while, she also studied at the Art Students League of New York.

During the Depression, Krasner obtained work through the Federal Art Project of the Works Progress Administration. As part of Franklin D. Roosevelt's New Deal (1933–43), the project provided financial support to female and male artists, and Krasner worked as an assistant on large-scale public murals, then advanced to a supervisory position; at one point, Pollock served as her assistant. In 1937, she took classes from Hans Hofmann (1880–1966), who showed her the work of Pablo Picasso and Henri Matisse, and helped her to modernise her approach. Hofmann once complimented Krasner, saying her work

was so good 'you wouldn't know it was made by a woman'.

In 1945, Krasner married Pollock and the duties of promoting and managing his career eclipsed her own. She continued painting, however, creating abstract works inspired by the grids of Piet Mondrian, with layers of thick paint and marks that evolved from her interest in the esoteric discipline of Kabbalah. She also intuitively painted from right to left, in the direction of Hebrew lettering, connecting with her subconscious. In the early 1950s, she began to experiment with collage. After Pollock died, her work was generally dismissed by critics for being derivative of Pollock's and too decorative. It was only towards the end of the twentieth century that her paintings were reappraised and appreciated. She and Pollock had a huge mutual impact on each other's artistic styles.

Was taught by

HANS HOFMANN

Experimented with the oscillation technique developed by

MAX ERNST

Was part of the Abstract Expressionist movement, which is heavily indebted to the ideas of

WITH HIS radical approach to painting, Jackson Pollock became the leading figure of the Abstract Expressionism movement that occurred in the United States during the 1940s and 1950s.

Pollock grew up in Wyoming, California and Arizona. At school in Los Angeles, he became interested in theosophy, and while living in Phoenix he became intrigued by Native American art. In 1930, he moved to New York and enrolled at the Art Students League, where he was taught by the Regionalist painter Thomas Hart Benton (1889–1975). After meeting the Mexican muralist José Clemente Orozco (1883–1949), spending a summer watching Diego Rivera paint murals at the New Workers School and joining the

Experimental Workshop of David Alfaro Siqueiros (1896–1974), he became increasingly fascinated by mural painting. In 1937, Pollock joined the Works Progress Administration's Federal Art Project, which had been set up to employ out-of-work artists during the Depression. He painted figuratively at the time, but after 1943, when the Federal Art Project ended, he began producing 'drip paintings', by throwing, flicking and pouring industrial paint onto large, unstretched, unprimed canvases on the floor, inspired by Surrealist automatism and the oscillation technique used by Max Ernst. In 1950, he said: 'New arts need new techniques. The modern artist cannot express this age; the airplane, the

Spent the summer of 1933 watching the painting of the Rockefeller Center by

atom bomb, the radio, in the old forms . . .' He walked around or on his canvases, dripping paint from above, or applying it with sticks and stiffened brushes to build up skeins, blobs and lines. Avoiding any pictorial representation, Pollock maintained that his improvisational paint application came directly from his unconscious, which was in turn connected to greater forces, so his art illustrated relationships between the self and the universe. He said he was articulating the concerns and energies of his age, expressing the era through dynamic gestures and spontaneity. 'When I am in my painting,' he once wrote, 'I'm not aware of what I'm doing. It is only after a sort of "get acquainted" period that I see what I have

been about.' Although much was left to chance, he asserted that he maintained control while he worked, and with no single focal point, his process became known as Action Painting. He was the first artist to combine European Modernism with a distinctly American way of painting.

In 1942, Pollock met Krasner's art tutor, Hans Hofmann, when she brought him to her husband's studio. Noting that there were no models, still lifes or other usual artists' paraphernalia, Hofmann asked Pollock: 'Do you work from nature?' To which Pollock replied: 'I am nature.' It was the start of a close friendship between the two men.

A PIONEERING artist and teacher, Hans Hofmann took modern European art ideas to the United States when he emigrated there in 1930. His own painting style fused various approaches, including elements of Cubism, the energy of Expressionism, Surrealist psychology and, most of all, bold Fauvist colour. Although his work appeared completely abstract, he always maintained links to the natural world.

While still a teenager, Hofmann began working for the director of public works of the State of Bavaria, where he patented several scientific inventions, including a radar device for ships. However, he soon left to study at Moritz Heymann's art school and also took private lessons with various artists, where he learnt Impressionist and Pointillist techniques. During that time, he met not only his wife but also Philipp Freudenberg, a Berlin department store owner and art collector who became his patron for the following decade. This provided him with the financial means to live in Paris, where he attended the Académie Colarossi and the Académie de la Grande Chaumière. In Paris, he befriended many of the German artists, dealers and intellectuals who met at the Café du Dôme on the Boulevard du Montparnasse, as well as Robert and Sonia Delaunay, Henri Matisse, Pablo Picasso, Georges Braque and André Derain. It was a time of intense artistic experimentation; Hofmann reflected that it was 'a baptism of fire'. He began exhibiting with the Berlin Secession and also had solo exhibitions; in 1910, he exhibited with the Austrian artist Oskar Kokoschka (1886–1980).

At the outbreak of the First World War, Hofmann returned to Germany and, disqualified from military service because of a lung condition, opened a summer school in Bavaria, which was

extremely successful. Its fame soon spread, and in 1930, he was invited to teach a summer session at the University of California. The following year, he returned to teach in the United States again and also held his first exhibition there. In 1932, he closed his Munich school and moved permanently to the United States, where he taught in several states and opened the Hans Hofmann School of Fine Art in New York. Meanwhile, his own painting continued to evolve, blending elements of mysticism and primitivism. Through his teaching, his art and his friendships, he had an extensive influence. In the summer of 1950, after receiving an inheritance, Helen Frankenthaler (1928–2011) took a short course with Hofmann, following the many artists who had studied with him and who were associated with Abstract Expressionism.

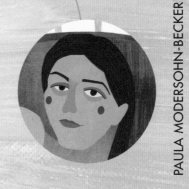

CAMILLE CLAUDEL

PAULA MODERSOHN-BECKER

HANS HOFMANN

WORKING WITH oils or acrylics, Helen Frankenthaler painted on large canvases using turpentine-thinned paint, producing clear washes of luminous colour that instigated the development of Colour Field painting, which became part of Abstract Expressionism.

Frankenthaler was born in New York. From the age of fifteen, she studied with various artists, and in 1950, she met the art critic Clement Greenberg with whom she began a romantic relationship. Greenberg introduced her to several leading Abstract Expressionists, including Willem de Kooning (1904–97), Lee Krasner, Jackson Pollock, Franz Kline (1910–62) and Hans Hofmann. In August 1952, while on holiday in Nova Scotia, she painted some small landscapes in watercolours and oils. On returning to her studio, she tacked a large, unprimed canvas onto the floor, as Pollock was doing, and made a few gestural marks in charcoal. Rather

than using enamel paint like Pollock, she poured on diluted oil paints, pushing them around with window wipers and sponges, creating translucent, veil-like shapes. Although aware of the general overall appearance she wanted, she worked intuitively and freely. At the end of the afternoon, she climbed on a ladder and looked down at her painting, later reflecting that she was 'amazed and surprised and interested'. The work, *Mountains and Sea*, was the first of her 'stain' paintings. Greenberg brought Morris Louis (1912–62) and Kenneth Noland (1924–2010) to see it at her studio, and they also began experimenting with the method. Frankenthaler was just twenty-three years old at the time, and she continued using her new method for decades, although she changed from oil paints to acrylics in the 1960s. She also experimented with printmaking and clay and steel sculpture, and designed sets and costumes for the English Royal Ballet. In the 1960s,

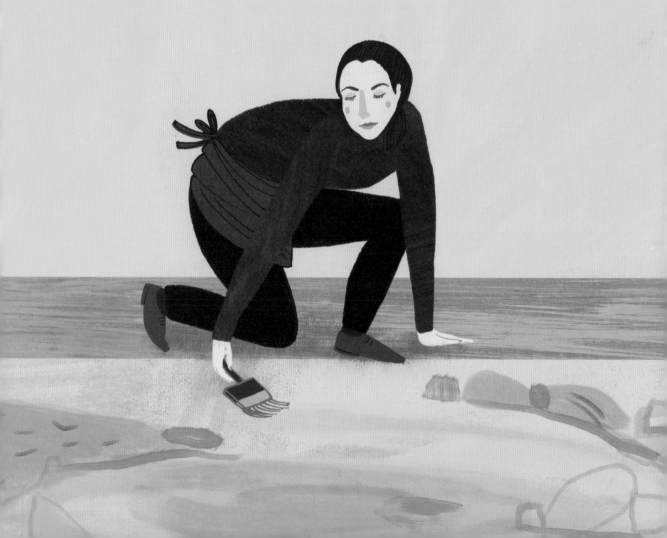

she began to include strips of colour near the edges of her paintings, and she also created single stains and blots of colour against white backgrounds. In the 1970s, she abandoned the soak-stain technique, instead applying thick, bright, opaque paint, and by the 1980s, she used more muted colours. Unlike Abstract Expressionism, Colour Field painting was devoid of emotional or personal content, and Frankenthaler's soak-stain method completely fused the paint with its canvas, drawing attention to the flatness of the painting itself.

Three years after breaking up with Greenberg, in 1957, she met Robert Motherwell (1915–91), who had already achieved international prominence as an Abstract Expressionist painter. They married a year later, and after their wedding, they spent several months touring Europe. They both came from privileged backgrounds, so were nicknamed 'the golden couple'.

LEE KRASNER

HELEN FRANKENTHALER

In New York in 1940, he met

MARCEL DUCHAMP

ROBERT MOTHERWELL grew up in California, where he developed a love of broad spaces, open skies and bright colours. As a child, he suffered with asthma, and in later life, themes of mortality frequently occurred in his art. Between 1932 and 1937, he briefly studied painting at the California School of Fine Arts in San Francisco and he also received a BA in philosophy from Stanford University.

When he was twenty, Motherwell travelled around Europe with his father and sister. Although he wanted to be a painter, his father urged him to pursue a more secure career. Later, Motherwell reflected: 'Finally after months . . . he made a very generous agreement with me that if I would get a PhD so that I would be equipped to teach in a college as an economic insurance, he would give me fifty dollars a week for the rest of my life.'

So Motherwell went to Harvard, and then studied art history at Columbia University under art historian Meyer Shapiro, who encouraged him to paint and introduced him to the European Surrealists who had escaped the Second World War and were living in New York. Fascinated by their notion of automatism – the idea that art could express an artist's subconscious – Motherwell began working in a similar way. Over the next two

decades, he taught at Black Mountain College in North Carolina, helped to establish an art school in New York's Greenwich Village and also taught at Hunter College. He wrote about his artistic theories for numerous publications.

Featuring simple shapes, bold colour contrasts and a dynamic balance between restrained and gestural brushstrokes, Motherwell's paintings, prints and collages reflect elements of art history, philosophy and contemporary art, while linking to his own life and experiences; they also explore such things as life, death and oppression. From 1961, he began to produce limited editions of his collages, in which he incorporated the detritus of his own daily life. His paintings became known for their sweeping strokes, straight and curving lines, and contrasts of light and dark, thick and thin, all exploring the philosophical themes that he had studied as a student.

Among the European Surrealists whom he met in 1940 were Marcel Duchamp, Max Ernst, André Masson and Yves Tanguy (1900–55). Although Motherwell was not involved with the political aspects of Surrealism, or with figurative subject matter, he was fascinated by the theory of psychic automatism, which he discussed with other practitioners in the group, including the eccentric and innovative Tanguy.

ROBERT MOTHERWELL

BEST KNOWN for his eerie paintings that blend fact and fantasy, Yves Tanguy explored the unconscious as if it were another world. A self-taught artist, Tanguy painted his childhood memories and dreams, as well as his own hallucinations and psychotic episodes. Mixing scale and perspective, naturalism and precision, his strange objects hover and float in his compositions, often in landscapes that resemble parts of Brittany where his mother lived.

When Tanguy was only eight years old, his father died. A few years later, his brother was killed in action during the First World War. His mother moved to Brittany, leaving Tanguy at school in Paris (although he joined her for the summer holidays). On leaving school, he signed up for the merchant navy, and two years later he was conscripted into the French army in Tunis, where he met the poet Jacques Prévert. When they returned to Paris, Tanguy and Prévert moved in with another friend, the writer Marcel Duhamel, and their home became a gathering place for artists and writers. In 1923, Tanguy saw *Le Cerveau de l'Enfant* (1914) by Giorgio de Chirico (1888–1978) in a gallery window and instantly decided to become a painter. In 1924, he met André Breton and attended the first Surrealist exhibition the following year. Breton wrote: 'What is Surrealism? It is the appearance of Yves Tanguy.' He also gave the artist a contract to paint twelve works a year for him and referred to the bizarre creatures in Tanguy's paintings as 'subject-objects'.

Tanguy's first solo exhibition was held in 1927 in Paris and the following year he exhibited with the Surrealists. In 1938, he went to London to hang his first retrospective exhibition in the UK at the Guggenheim Jeune gallery. It was a great success and Peggy Guggenheim wrote in her autobiography: 'Tanguy found himself rich for the first time in his life.' After 1930, he began

to incorporate images of geological formations that he had observed during a trip to Africa, and he also began to exhibit extensively, both solo and in Surrealist group shows in New York, Brussels, Paris and London. In 1940, he moved to Connecticut, and over the next few years, he exhibited in Rome, Milan and Paris.

In 1936, Tanguy exhibited at the International Surrealist Exhibition at the New Burlington Galleries in London. Among the 23,000 visitors was nineteen-year-old Leonora Carrington (1917–2011). As it was the first time she had seen Surrealist works at close hand, it was a pivotal moment for her. Among those who particularly inspired her were Man Ray (1890–1976), Max Ernst and Tanguy.

JOAN MIRO

Had artworks destroyed by right-wing activists in December 1930, as did

YVES TANGUY

Was a guest at the second wedding of

FRIDA KAHLO

DIEGO RIVERA

A KEY figure in the Surrealist movement, who created detailed paintings of fantastic creatures in dreamlike settings, the English-born artist Leonora Carrington lived most of her adult life in Mexico City and was a founding member of the Women's Liberation Movement in Mexico during the 1970s. Fascinated by the unconscious mind, she explored themes of transformation and identity, drawing on her life and friendships to represent women's self-perceptions, the sisterhood between women, and female figures in male-dominated environments.

Carrington grew up surrounded by animals in Lancashire, England, where her Irish nanny told her fairy tales and Celtic folk stories, which later inspired her artwork. Educated by a succession of governesses, tutors and nuns, she was expelled from two convent schools for bad behaviour and was sent to study art briefly in Florence. In 1935, she attended the Chelsea School of Art in London, but then transferred to the Ozenfant Academy of Fine Arts, also in London, established by French Cubist painter Amédée Ozenfant (1886–1966). She was inspired by two books: a memoir by the female explorer Alexandra David-Néel, a spiritualist and a Buddhist who visited Tibet disguised as a man in 1924 when it was forbidden to foreigners, and *Surrealism* (1936) by Sir Herbert Read.

In 1936, Carrington visited the International Exhibition of Surrealism in London. A few months later, she met Max Ernst at a party. He left his wife, and he and Carrington travelled to Paris, then settled in Saint-Martin-d'Ardèche in southern France where they worked closely together. However, when the Second World War broke out, Ernst was arrested twice in German-occupied France and eventually fled to the United States with Peggy Guggenheim. Carrington, who was in Spain, suffered a mental breakdown and was institutionalised and treated with shock therapy. Traumatised, she sought refuge in Lisbon's Mexican embassy, and three years later, she painted and wrote about her psychotic experience and ruthless treatment. In 1941, she married the Mexican poet and diplomat Renato Leduc and moved to Mexico. However, they soon divorced, and she married again.

Carrington participated in an international exhibition of Surrealism in New York where her work was highly acclaimed. She worked in a range of media, including painting, printmaking and sculpture, and also wrote articles, short stories and two novels. Although the two artists never met, the work of Carrington and Franz Marc was informed by similar things, such as personal life experiences, spirituality, mysticism and animals. Whereas Carrington was also inspired by Carl Jung, Buddhism and the Kabbalah, Marc was drawn to theosophy.

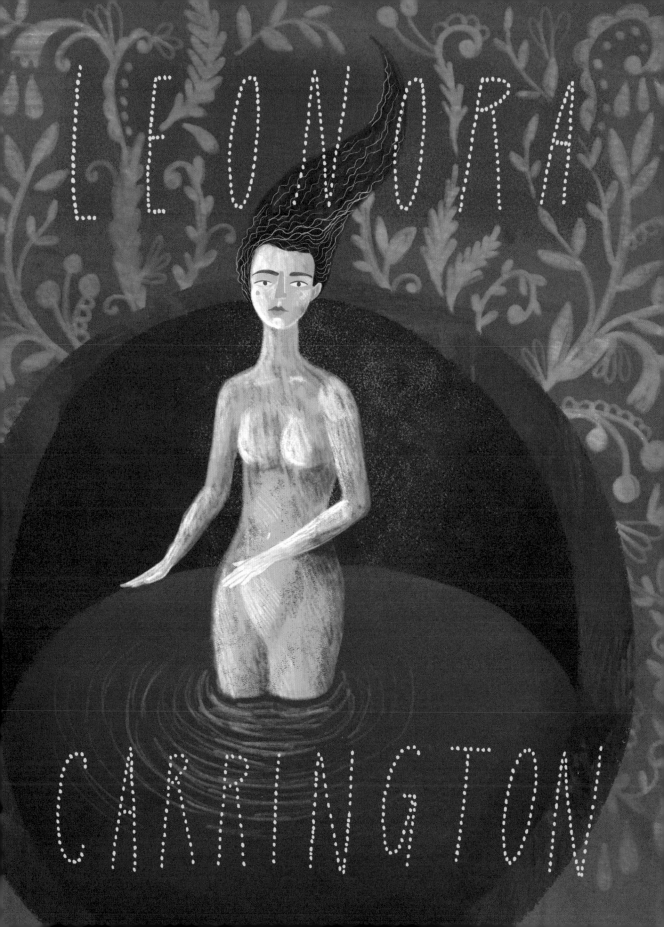

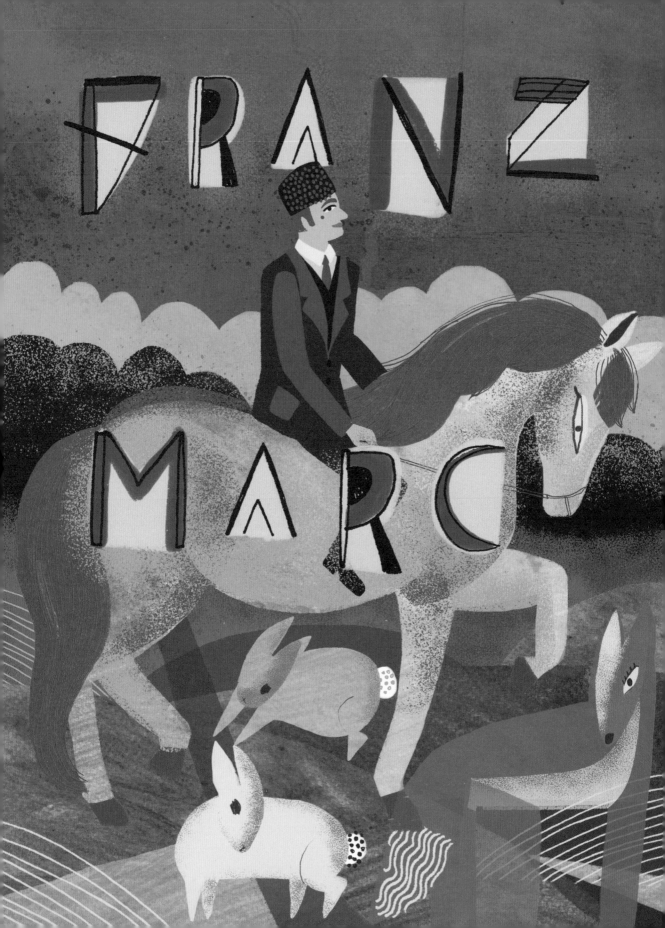

Founded der Blaue Reiter with

A PIONEER of German Expressionism, Franz Marc depicted his beliefs that animals were innocent victims of human thoughtlessness and arrogance. Like many other artists of his generation, he felt that 'primitivism', or a naïve style, expressed his ideas more honestly than idealism or naturalism. In 1911, he and Wassily Kandinsky founded der Blaue Reiter (the Blue Rider), both a journal and a group of artists who believed in creative freedom.

Marc first studied philosophy in his home town of Munich and then enrolled at the Munich Academy of Fine Arts. As soon as he left, he began to move away from the realism he had been taught and used bold colours, expressive brushmarks and angular shapes. In 1903 and 1907, he spent several months in Paris, studying the work of the Impressionists and the Post-Impressionists. In 1905, he met the Swiss artist Jean-Bloé Niestlé (1884—1942) and was inspired by his animal paintings. He was also inspired by the expressiveness of the art of Vincent van Gogh, the vibrant colours of the Fauves and the multiple viewpoints of Cubist and Futurist imagery. After meeting Robert Delaunay, he experimented with simultaneous colour contrasts, juxtaposing complementary colours to create brighter effects, and also began producing lithographs and woodcuts.

In 1910, Marc became friends with August Macke and Kandinsky, who were focusing on spirituality and mysticism, which they expressed through colour. Marc began to experiment with his own personal colour theory, which he described: 'Blue is the male principle, astringent and spiritual. Yellow is the female principle, gentle, happy and sensual. Red is matter, brutal and heavy and always the colour to be opposed and overcome by the other two.'

Marc also closely studied the anatomy of animals, from books and in Berlin Zoo. For him, animals represented truth, purity, beauty and innocence. He said: 'An animal's unadulterated awareness of life made me respond with everything that was good.' He soon became known for his images of vividly coloured animals, which conveyed profound messages about humanity and the fate of humankind. It was his own spiritually inspired symbolism that he felt called attention to what he saw as the terrible state of the modern world. Tragically, Marc and Macke were both killed in action during the First World War.

Before the war, in Paris, Marc witnessed the evolution of Cubism. Another foreign artist who was also in Paris during that time was Aleksandra Ekster. Both artists went on to produce dynamic and vibrant compositions, greatly inspired by their Parisian experiences and by the art that was evolving around them, but with different interpretations.

BORN IN Russia to a wealthy Belarusian businessman and a Greek mother, Aleksandra Ekster lived in Kiev, Saint Petersburg, Moscow, Vienna and Paris, painting in various styles, including Cubo-Futurist, Suprematist and Constructivist, and designing theatre and film sets. At Kiev Art School, she met the sculptor Alexander Archipenko, among others. In 1908, she married a successful lawyer and spent several months with him in Paris, where she attended the Académie de la Grande Chaumière, although she was expelled for not following the academy's artistic direction.

On her return to Russia, Ekster began exhibiting – first in Kiev and then in Saint Petersburg – with other artists, including David Burliuk (1882–1967), Mikhail Larionov (1881–1964), Natalia Goncharova (1881–1962), Jean Metzinger, Albert Gleizes and Marcel Duchamp. Initially, she painted in an Impressionistic style, then she painted Cubist-type cityscapes; later, she assimilated elements of Cubism and Futurism. Gradually, Ekster became more abstract, always using a vibrant palette and rhythmic compositions. In 1914, she participated in the International Futurist Exhibition in Rome and the following year she joined a Russian group of avant-garde artists called Supremus. In France she befriended both Pablo Picasso and Georges Braque, as well as the poet and critic Apollinaire, and worked tirelessly and diversely, becoming a successful theatre set,

costume and puppet designer and also a book illustrator. In 1921, she exhibited in Moscow with the Constructivists at the '5x5=25' exhibition; also in Moscow, she taught at the Higher State Artistic-Technical Workshop (VkhUTEMAS) and was soon appointed director of the elementary course on colour. Her costume designs were colourful and flowing; similarly, the free-flowing brushstrokes in her paintings show how she constantly strove to recreate dynamic effects. Her theatre sets were also experimental and colourful, and she began mass-producing her own fashion designs in 1921.

In 1924, Ekster emigrated to France and settled in Paris, where she taught at the Académie Moderne. She collaborated on a science fiction film with the Russian film-maker Yakov Protazanov, and in 1925, she helped to set up the Soviet pavilion at the Parisian Exposition Internationale des Arts Décoratifs et Industriels Modernes, which heralded the Art Deco style. From 1926 to 1930, she taught at the Académie d'Art Contemporain, established by Fernand Léger, and began to create intricate illuminated manuscripts in gouache on paper.

In 1914, Ekster exhibited at the Salon des Indépendants in Paris. Particularly in evidence at that year's exhibition were Orphist paintings, filled with light, bright colours and angled planes. Among Ekster's fellow exhibitors were Archipenko, Sonia Delaunay-Terk and Kazimir Malevich (1879–1935).

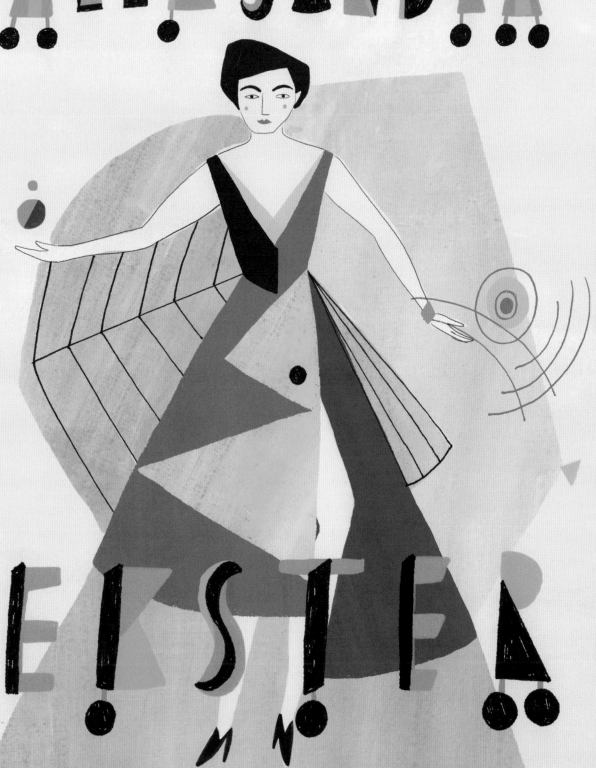

KAZIMIR MALEVICH explored a variety of art styles before inventing Suprematism, a completely abstract concept that had a powerful influence on the evolution of modern art.

During his childhood, Malevich moved frequently around Ukraine, and his first paintings reflected the peasant art and embroidery with which he was familiar. He first studied art in Kiev, and after his father's death in 1904, he moved to Moscow with his mother, wife and children, continuing to study at the Moscow School of Painting, Sculpture and Architecture, where he was taught Impressionist and Post-Impressionist techniques by Leonid Pasternak (1862–1945) and Konstantin Korovin (1861–1939). His paintings at that time displayed elements of Post-Impressionism, Symbolism and Art Nouveau, but after befriending some Russian avant-garde artists, he began to explore Primitivism, Cubism and Futurism. He joined several art groups, including the Jack of Diamonds, Donkey's Tail,

Target and the Union of Youth (Soyuz Molodezhi) in Saint Petersburg, and developed a dynamic, deconstructed style of Cubo-Futurism. In 1913, after seeing the paintings of Aristarkh Lentulov (1882–1943), Malevich designed costumes and a set for the Futurist opera *Victory Over the Sun* in Saint Petersburg, which made him an instant celebrity. He also exhibited at the Salon des Indépendants in Paris, and then published his manifesto *From Cubism to Suprematism*, which explained that art should express pure sensation and be devoid of any illusory or representational tricks. He invented the term 'Suprematism' because he believed that art should transcend subject matter; shape and colour should reign 'supreme'. Comprising geometric forms and flat colour, Suprematist compositions openly demonstrated that they were made of paint, and also aimed to inspire thoughts about time and space.

From December 1915 to January 1916, an exhibition was held in Saint Petersburg called

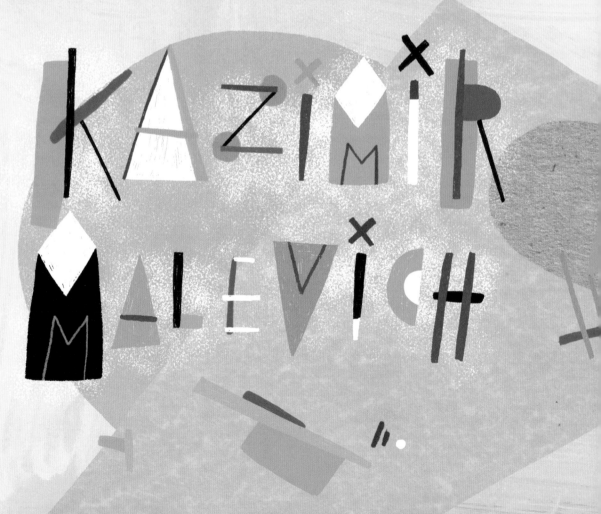

'The Last Futurist Exhibition of Painting 0.10 (Zero Ten)'. Malevich exhibited paintings that abandoned all references to the visual world, with plain, coloured or monochrome geometric shapes on white backgrounds. After the October Revolution of 1917, he joined the fine art department of the People's Commissariat for Enlightenment, known as IZO. He also taught at the Free Art Studios (SVOMAS) in Moscow, instructing his students to abandon representation and instead explore radical abstraction.

When he first moved to Moscow, Malevich had befriended other artists, including Wassily Kandinsky and Mikhail Larionov. Among other Russian artists, Larionov and Malevich aspired to develop a uniquely Russian form of Modernism, and it was Larionov who invited Malevich to join his exhibition collective the Jack of Diamonds. The following year, Malevich exhibited with the Donkey's Tail, another breakaway group started by Natalia Goncharova and Larionov.

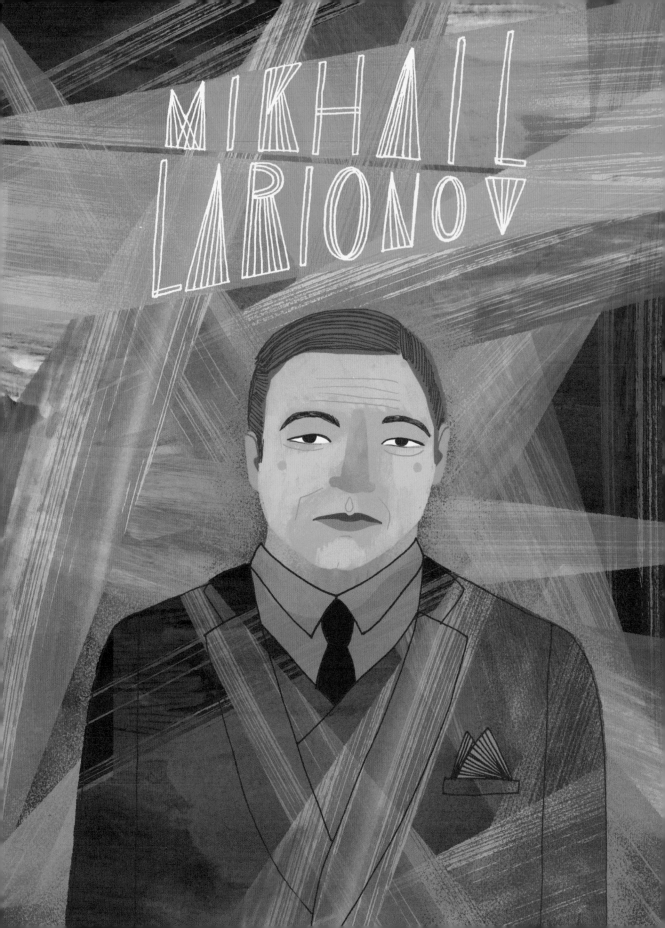

In 1908, organised the Golden Fleece exhibition in Moscow, which included works by

THE RUSSIAN-BORN French painter and stage designer Mikhail Larionov was a pioneer of pure abstraction in painting. Influenced early on by Impressionism and Symbolism, his own non-representational style was a stylistic fusion of Cubism, Futurism and Orphism.

Larionov was born in Ukraine, and at the age of seventeen he began studying at the Moscow School of Painting, Sculpture and Architecture. Two years later, he met fellow student Natalia Goncharova and they began their long-term collaboration and partnership. In 1906, he exhibited his Impressionist-style landscapes in the Russian art exhibition at the Salon d'Automne in Paris, and helped to organise an exhibition of modern French painting in Moscow. After the exhibition, Larionov and several other Russian artists began to experiment with Post-Impressionist ideas. In 1910, Larionov was expelled from the Moscow School of Painting for organising a demonstration against its teaching methods, and he founded the Jack of Diamonds group for Russian artists who were interested in Primitivism and folk art. He soon left the group for the more radical Donkey's Tail, which he co-founded with Goncharova, focusing solely on Russian Primitivism. He also initiated two influential movements: Rayonism, which was inspired by Italian Futurism, and Neo-Primitivism, which was a synthesis of aspects of

Fauvism and Expressionism, in which he painted with broad strokes of bright colour and from multiple perspectives.

In 1914, Larionov moved to Paris, but returned to Russia at the start of the First World War and was drafted into the army. Within a short time, however, he was injured and spent three months in hospital. The injury affected his ability to concentrate and sapped his creative energy. Then Sergei Diaghilev asked him to go to Switzerland and design costumes for his Ballets Russes. Larionov's subsequent opulent, colourful costumes established his reputation.

In 1919, Larionov settled in Paris, where he collaborated with Cubist and Dadaist painters and poets, and in 1928 he organised the first major exhibition of modern French art for the Soviet Union, at Moscow's Tretyakov Gallery. He was also producing graphic work and illustrations, although he continued to work for Diaghilev as a designer and artistic advisor. He did not return to painting until after Diaghilev's death in 1929.

Larionov met Goncharova when they were both nineteen and still students. With their shared artistic philosophies, they fell in love and stayed together for the rest of their lives. After they moved to Paris permanently from 1919, Larionov acted as Goncharova's manager, organising her exhibitions and sales of her work.

LIGHT, BRIGHT, angular shapes and colours, often representing monumental figures, are all elements of Natalia Goncharova's work. One of the pioneering twentieth-century Russian avant-garde artists, she developed Rayonism: paintings that focus on the deconstruction of rays of light.

A descendant of the poet and novelist Aleksandr Pushkin, Goncharova grew up on her grandmother's large estate in the country. At the age of nineteen, she enrolled at the Moscow School of Painting, Sculpture and Architecture, where she met and fell in love with Mikhail Larionov. In 1906, she participated at a World of Art exhibition, and Sergei Diaghilev invited her to exhibit in his Salon d'Automne show in Paris. She soon encountered the art of Paul Gauguin, Henri Matisse, Paul Cézanne and Henri de Toulouse-Lautrec, which aroused her sense of colour. In 1910, she was one of the founding members of the Jack of Diamonds, Moscow's first

exhibiting group of avant-garde Russian painters. That year she had her first solo exhibition, but it was denounced by the press for its 'disgusting depravation'. The police confiscated two female nudes and her *God(dess) of Fertility* (1909) painting; she was put on trial for pornography and later acquitted. In 1911, she began to exhibit with the German-based group der Blaue Reiter (the Blue Rider), which aimed to merge spirituality with expressive freedom. She and Larionov also founded Donkey's Tail, another artists' collective, which included Marc Chagall and Kazimir Malevich.

Goncharova began to paint icons, which were denounced by the Church amid great controversy. Meanwhile, she was labelled disreputable for living with Larionov when they were not married. In addition, she often wore men's clothing and sometimes went topless in public with designs painted on her breasts. From 1914, she travelled

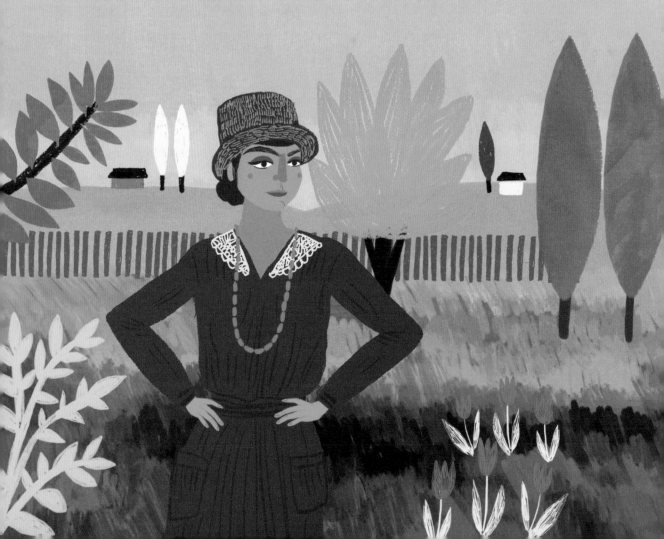

around Europe, designing stage sets and costumes for Diaghilev's Ballets Russes. After the Russian Revolution, she and Larionov moved permanently to Paris, and throughout the 1920s her paintings were influenced by her stage designs and travels. During the Second World War, she travelled and designed for ballets in South Africa, and after the war, divided her time and work between London and Paris. During the 1950s, severe arthritis made it necessary for her to tie her brush to her hand in order to paint. She was one of numerous inspiring women represented in the installation *The Dinner Party* (1974–79) by Judy Chicago (b.1939). She is featured on the 'Heritage Floor' along with the names of 998 other women, each inscribed on white handmade porcelain floor tiling.

FRANZ MARC

Was one of the earliest members of the avant-garde group der Blaue Reiter, founded by

NATALIA GONCHAROVA

JUDY CHICAGO

The most prominent plate in her installation *The Dinner Party* features

Was a trailblazer in Feminist art in the 1960s and 1970s alongside

IN THE 1970s, Judy Chicago helped to pioneer Feminist art, a movement that aimed to improve female artists' prominence in the art world. Through her use of traditional female skills, such as embroidery and appliqué, she created art focusing specifically on female themes, most famously in her work *The Dinner Party* (1974–79), which celebrates the achievements of many women throughout history.

Judy Cohen was born in Chicago, Illinois, into a family where both parents worked, which was unusual for the time. Her father was involved with the US Communist Party, and his liberal opinions about women and his support of workers' rights influenced his daughter's views. Having taken art classes in Chicago as a child, she later attended the University of California in Los Angeles, completing a master's degree in painting and sculpture in 1964. Her early paintings were bold and expressive, and she subsequently produced large clay sculptures. During the 1960s, she began to gain recognition for her Minimalist, geometric works, and in 1966, she participated in the groundbreaking exhibition 'Primary Structures: Younger American and British Sculptors' at the Jewish Museum in New York City. After the deaths of both her father and her first husband, she changed her surname to 'Chicago'.

In 1971, she and fellow artist Miriam Schapiro (1923–2015) ran a women-only art course at the California Institute of the Arts in Valencia, California, aiming to start redressing the balance

GEORGIA O'KEEFFE

EVA HESSE

JENNY HOLZER

of the male-dominated history of art. From this emerged Womanhouse, an art space they created with their students in Los Angeles; it was a place for women to teach, perform, exhibit and discuss. In 1973, also in Los Angeles, Chicago established the Feminist Studio Workshop.

The following year, she began her monumental work *The Dinner Party*, seeking to incorporate female artists' stories into the chronology of art history. Using creative techniques that are generally dismissed as female crafts, she worked collaboratively with artisans – creating such things as ceramic decoration and embroidery – to produce a huge installation that celebrated many undermined and overlooked women in history. However, the work was rejected by critics

as offensive and vulgar, and it was dismantled and stored away for nearly thirty years. Despite its championing of females, not all women approved. Some complained that Chicago's overriding representation of female achievement was the vagina. Others applauded it as a demonstration of feminine accomplishment. Chicago invented the term 'Feminist art' and among her inspirations for *The Dinner Party* were several ideas from the avant-garde artist Méret Oppenheim (1913–85), including a fur-covered teacup and saucer that she called *Object* (1936).

Attended the Académie de la Grande Chaumière, as did

BROUGHT UP in a family of psychoanalysts in Germany and Switzerland, Méret Oppenheim kept a dream diary throughout her life, and these ideas fuelled her later work. In 1929, she began studying at the Kunstgewerbeschule in Basel. The following year, she moved to Paris, briefly attended the Académie de la Grande Chaumière and befriended the older artists Alberto Giacometti, André Breton, Man Ray and Jean (Hans) Arp. That year, she exhibited three paintings at the Salon des Surindépendants with her new friends, modelled for Man Ray and had a brief romantic relationship with Max Ernst. After that, she participated in Surrealist exhibitions in Copenhagen, Tenerife, London and New York.

In the spring of 1936, Oppenheim designed a fur-covered bangle for the fashion designer Elsa Schiaparelli and was wearing one when she met Pablo Picasso at the Café de Flore on the Boulevard Saint-Germain. They discussed what else could be covered with fur, and Oppenheim later covered a teacup, saucer and spoon with it. Titled *Objet (Le Déjeuner en Fourrure)* (1936) or *Object (The Luncheon in Fur)*, she exhibited the work at the first Surrealist exhibition at the Museum of Modern Art in New York. It caused a sensation, but Oppenheim was overwhelmed. Intensely depressed, she returned to Switzerland, believing

that the commotion caused by *Object* would restrict her artistic development. She stopped creating art for nearly twenty years.

In 1954, Oppenheim suddenly recovered her 'pleasure in making art' and began writing and producing art again. Two years later, she designed costumes for a production by Daniel Spoerri (b.1930) of Picasso's play *Desire Caught by the Tail* (1941). At the end of 1959, she put on a performance at the Exposition Internationale du Surréalisme in Paris, but was upset when it was criticised for objectifying women and she never exhibited with the Surrealists again. She maintained that the key task of the female artist was 'to prove via one's lifestyle that one no longer regards as valid the taboos that have been used to keep women in a state of subjugation for thousands of years'.

Over her career, Oppenheim created jewellery, sculpture, paintings, furniture, performance art, poetry and even fountains. In 1967, a large retrospective of her work was held in Stockholm and she was awarded prestigious prizes in Basel and Berlin. In 2013, Marlene Dumas (b.1953) held a joint exhibition with Luc Tuymans (b.1958) in Antwerp. Among the works that Dumas displayed was a copy of a Man Ray photograph of Oppenheim.

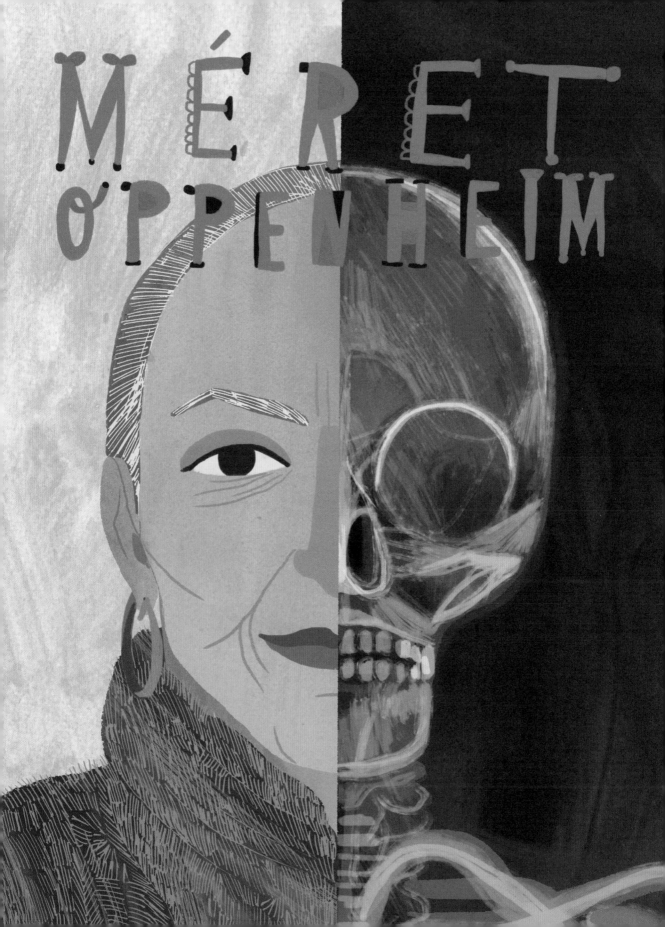

ALBERTO GIACOMETTI

won the Grand Prize for Sculpture at the 1962 Venice Biennale, where Dumas exhibited thirty-three years later

A SOUTH African artist who has lived in Amsterdam since 1976, Marlene Dumas works prolifically. She grew up on the Western Cape and studied art first at the University of Cape Town, then at Ateliers '63 (now known as De Ateliers) in Haarlem in the Netherlands. From 1979, she studied psychology for a year at the University of Amsterdam, and both these areas of study informed the figurative paintings that she creates using a diverse range of sources, including personal memorabilia, Polaroid photographs, newspaper and magazine cuttings, letters and Flemish paintings that she studies in museums. Initially, she produced paintings, collages, drawings, prints and installations, but Dumas now works mainly with oil on canvas and ink on paper. Her subjects have included babies, models, strippers and friends, as well as figures from politics and popular culture. At first glance, many of these works appear to be portraits, but they do not represent superficial observations. Instead, most portray an emotion or a state of mind as well as other underlying themes, including race, sexuality, political oppression, guilt, innocence, identity, violence and feminism.

Much of Dumas's work is informed by her childhood experiences growing up in South Africa within apartheid, the racist political system of segregation and discrimination that lasted from 1948 until the early 1990s. Arising from this, her paintings seek to address many struggles experienced by those who are oppressed. Her work ignores the conventions of portraiture, instead exposing misunderstandings that can occur between depiction and interpretation. With gestural brushstrokes and thin paint, her semi-transparent images emphasise notions of impermanence and intimacy while conveying her uncomfortable themes. She has also produced several works during moments of personal emotional distress and has used her entire body to make marks, combining them with images torn from magazines and pinned to the surfaces of her paintings.

In 1995, Dumas represented Holland in the Venice Biennale, and her first major exhibition in the United States was in 2008, a retrospective titled 'Measuring Your Own Grave', at the Museum of Contemporary Art, Los Angeles, and then at the Museum of Modern Art in New York City. In 1991, she created the series *Portrait Heads*, comprising hundreds of black and white portraits. Some were exhibited later that year as *Black Drawings*. In these, Dumas explored black as a colour, ink as a medium, and also once again specifically made reference to the racism and inequalities of apartheid. Similarly, the US artist Kara Walker (b.1969) confronts notions of race, gender, sexuality and violence, often using only black and white.

WORKING WITH collage, drawing, painting, performance, film, video, sculpture, light projection and paper cut-out silhouettes, Kara Walker creates disconcerting imagery to explore uncomfortable concepts, predominantly focusing on black history.

After graduating from Atlanta College of Art in 1991, Walker attended Rhode Island School of Design. While studying there, she began working with the Victorian method of cut-paper silhouettes to explore themes of slavery, violence, sex and stereotyping. Since then, she has continued to explore similar themes, frequently using the same process. Her reference sources include books, films and cartoons, while her refined, often dainty-looking images force viewers to confront the disquieting content. Her earliest cut-paper silhouette mural grabbed the art world's attention. *Gone: An Historical Romance of a Civil War as It Occurred*

Between the Dusky Thighs of One Young Negress and Her Heart (1994) mocks Margaret Mitchell's novel *Gone with the Wind* (1936), which romanticises the situation of slaves in nineteenth-century America. While the novel and film depict plantation slaves accepting their circumstances quite happily, Walker strips the sentiment, revealing cruelty, violence, rape and other injustices, thus exposing the true hopelessness of life for the slaves.

Currently living in New York City, Walker has taught extensively at Columbia University and was elected to the American Philosophical Society in 2018. She continues to challenge viewers to reconsider and reflect on racial inequality. Her lengthy, literary titles and her use of the silhouette, which has for so long been associated with middle- and upper-class white people, parody these histories. She creates further discomfort by emphasising physical stereotypes in

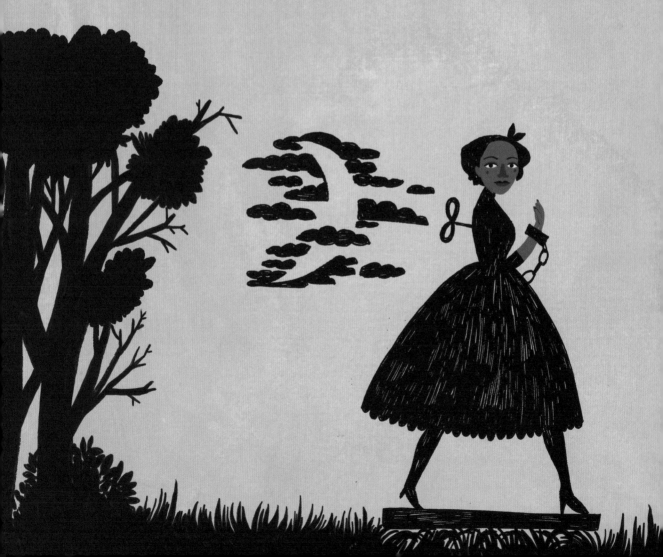

her images, including curly hair, fuller lips and flatter profiles for the black figures, and straighter noses, thinner lips and longer hair for the white figures. In this way, she clearly distinguishes the victims and the villains, but also the hierarchy that was established during the slave trade relating to race and gender. Her stereotypes crudely remind viewers of the inequality, exploitation and abuse; because they are silhouettes rather than detailed images, ambiguities persist, compelling viewers to question what they know about racism, and the social and economic inequalities that persist across the United States.

In the development of her narrative images, Walker draws on facts as well as on folk history, fairy tales and historical fiction. For almost seventy years, Paula Rego (b.1935) has worked with similar resources for her art, yet the methods and appearance of the two artists' work differs greatly.

As a child, she adored

ANDY WARHOL

KARA WALKER

BEN NICHOLSON

briefly went to the Slade School of Art, where Rego later studied

RENOWNED FOR her paintings, prints, drawings and collages based on fairy and folk tales, literature and autobiography, and her characteristic use of pastels over more traditional oils, Paula Rego creates bold, expressive, figurative paintings, often with disquieting underlying themes.

As a baby, Rego remained in Lisbon in the care of her grandmother when her parents moved to London for her father's work. They returned to Portugal a few years later and moved to the seaside town of Estoril, spending summers in the fishing village of Ericeira. At the age of sixteen, Rego was sent to a finishing school in the UK, but within a year, she left and enrolled at the Slade School of Fine Art in London, where she met her future husband, mature art student Victor Willing (1928–88). In the early 1950s, she exhibited with the London Group, who aimed to show work by women and foreign artists who were so often ignored by the mainstream art world. In 1957, Rego and Willing left London to live in Ericeira. They married two years later following Willing's divorce from his first wife, and they divided their time between Portugal and London. In 1965, although the catalogue was censored, Rego's first solo show in Lisbon was praised for its freedom of expression. The following year, her father died

and Willing was diagnosed with multiple sclerosis, but Rego's career was ascending and she exhibited widely, at the time often working in collage. In 1976, they moved to London permanently. Willing died in 1988, and that same year, Rego was the subject of a retrospective exhibition in Lisbon and London.

A prolific worker, Rego says she is fascinated by 'the beautiful grotesque' in life and art. Her early style was influenced by Surrealism, but she has always retained a strong narrative element, often featuring disconcerting scenes and exploring difficult relationships and social complications. After 1990, her work changed from a loose, painterly style to firmer, smooth-contoured forms. She abandoned collage in the late 1970s, and in 1994, she became captivated by the immediacy of pastels: she applies hard pastels first, sometimes creating indentations through pressure, then adds layers of soft pastels over the top. Her studio contains costumes for her models, as well as mannequins and toys that she uses as props. Rego's artistic career ascended while she was still studying at the Slade School of Fine Art in the 1950s. Just over twenty years later, another successful female artist, Mona Hatoum (b.1952), also studied there.

Paula
Rego

Her 1995 work, *Van Gogh's Back*, directly nods to the influence of

VINCENT VAN GOGH

A MULTIMEDIA and installation artist, Mona Hatoum frequently explores conflicts, contradictions and human struggles related to inequality, or feelings of being an outsider. She first became known in the mid-1980s for her series of performances and videos that focused on the body. In the 1990s, her work moved more towards large-scale installations and sculptures.

Hatoum was born and grew up in Beirut and she studied graphic design at Beirut University College, then took a job in an advertising agency. However, during a visit to London in 1975, civil war broke out in Lebanon, so she remained in London and studied art, first at the Byam Shaw School of Art and then at the Slade School of Fine Art. Her first work was a performance, using the human body in response to the plight of Palestine and the war in Lebanon, specifically focusing on the vulnerability and powerlessness of individuals, and conveying her thoughts about torture, separation and oppression. She continued to produce performances until the late 1980s, when she turned her attention to installations and sculpture, using a diverse and often unconventional range of media, including familiar everyday items that she often transforms into seemingly worrying or threatening things. Focusing mainly on installations, she continues to explore themes of politics, war, gender, exile,

violence and the dangers and restrictions of the domestic world.

With its unexpected juxtapositions, her art is frequently unsettling and confrontational, with many of her concepts deriving from her Middle Eastern heritage and her adult life in Europe. Hatoum builds on the notion of encouraging involvement and interaction among viewers. Her work can be completely unexpected, such as *Corps Étranger* of 1994, for which she swallowed an endoscopic camera. The resulting video is a film of the interior of her body, projected on the floor of a cylindrical structure that the viewer enters through one of two narrow doors situated at either end, accompanied by a soundtrack of heartbeats as they can be heard from different parts of the body. This total immersive experience for viewers demonstrates an important aspect of Hatoum's work: to stimulate physical and emotional responses among viewers.

In 1998, Hatoum reflected: 'Eva Hesse [1936–70] was very much a model figure for my generation of women artists. She was around when Minimalism was happening, but her work was so much more organic and to do with the body. Someone once made a parallel between my *Socle du Monde* [1992–93] and the series of cubes Eva Hesse made, which she called *Accession* [1967–69].'

EVA HESSE was a painter and sculptor, who used unusual materials such as rubber tubing, fibreglass, textiles, synthetic resins and wire. Her career was prolific yet short; she died of a brain tumour at the age of thirty-four.

In 1939, the Hesse family were forced to flee Nazi persecution in Germany, and Eva and her sister were separated from their parents when she was only two. The little girls were put on a train to Holland. Five months later, the family was reunited in England and they eventually settled in New York, but life was still difficult. Hesse's father had been a successful lawyer in Hamburg, but it was hard for him to obtain work in the United States. Depressed by their unwanted exile and reduced circumstances, Hesse's mother killed herself when Hesse was ten years old.

Six years later, Hesse finished her studies at New York's School of Industrial Art. For a short time, she studied at the Pratt Institute, then took classes at the Art Students League of New York. She also studied at Cooper Union and at Yale University, where she was taught by the principal of the time, Josef Albers. Back in New York, Hesse befriended various other young artists, including Sol LeWitt (1928–2007), Donald Judd and Yayoi Kusama, who all inspired her to explore spatial relationships and many established concepts of art.

Hesse began her career by painting Abstract Expressionist-style paintings, using thick impasto paint in fluid shapes, aiming to convey emotion and creating a new kind of abstract painting. However, in 1966, she abandoned painting, deciding instead to investigate the sculptural possibilities of the

commercial materials that were lying around the disused factory that she and her husband were using as a temporary studio. She began to experiment with these industrial and 'found' materials, creating tension through her focus on contrasts, contradictions and oppositions. She said she wanted to achieve a kind of 'non-art', to push the boundaries of possibility and logic as far as they could go. She continued experimenting, constantly developing innovative working methods, and when she had invented a new process, she would repeat it almost obsessively. She later became classified as a Post-Minimalist, a term that describes a range of styles associated with Minimalism, yet often with different focuses; it can include Performance art, Body art and aspects of Conceptual art.

YAYOI KUSAMA

Brimming with creative inspiration, how-to projects and useful information to enrich your everyday life, Quarto Knows is a favourite destination for those pursuing their interests and passions. Visit our site and dig deeper with our books into your area of interest: Quarto Creates, Quarto Cooks, Quarto Homes, Quarto Lives, Quarto Drives, Quarto Explores, Quarto Gifts, or Quarto Kids.

First published in 2019 by White Lion Publishing
an imprint of The Quarto Group
The Old Brewery, 6 Blundell Street
London N7 9BH
United Kingdom

www.QuartoKnows.com

A catalogue record for this book is available from the British Library.

ISBN 978 1 78131 843 0
Ebook ISBN 978 1 78131 844 7

10 9 8 7 6 5 4 3 2 1
2023 2022 2021 2020 2019

Typeset in MrsEaves
Design by Paileen Currie

Printed in China